The *Photographer's Market* Guide to
Photo Submission and Portfolio Formats

Michael Willins

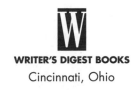

WRITER'S DIGEST BOOKS
Cincinnati, Ohio

The Photographer's Market Guide to Photo Submission & Portfolio Formats.
Copyright © 1997 by Michael S. Willins. Manufactured in the United States of America.
All rights reserved. No part of this book may be reproduced in any form or by any
electronic or mechanical means including information storage and retrieval systems
without permission in writing from the publisher, except by a reviewer, who may
quote brief passages in a review. Published by Writer's Digest Books, an imprint of
F&W Publications, Inc., 1507 Dana Avenue, Cincinnati, Ohio 45207. (800) 289-0963.
First edition.

Other fine Writer's Digest Books are available from your local bookstore or direct
from the publisher.

01 00 99 98 97 5 4 3 2 1

Library of Congress Cataloging-in-Publication Data

Willins, Michael.
 The photographer's market guide to photo submission & portfolio formats /
 Michael Willins.
 p. cm.
 Includes bibliographical references and index.
 ISBN 0-89879-758-6 (alk. paper)
 1. Photography—Marketing. 2. Stock photography.
TR690.W55 1997
770'.068'8—dc21 97-25182
 CIP

Edited by David Borcherding
Production edited by Jennifer Lepore
Cover and interior designed by Chad Planner

The permissions on page iii constitute an extension of this copyright page.

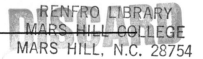
PERMISSIONS

BKT Photography letterhead and business card samples on page 10. Courtesy of Hal Barkan, Cincinnati, OH. Used by permission.

Terms & Conditions sample on pages 19–20. Courtesy of Rob Buenning, Overland Park, KS. Used by permission.

Starfish Records tearsheet sample on page 29. Courtesy of Starfish Records, Cincinnati, OH. Used by permission.

Chapter 3, Pricing and Negotiating, on pages 35–41. Reprinted with permission from the *1997 Photographer's Market: Where & How to Sell Your Photographs*, Writer's Digest Books, edited by Michael Willins. Used by permission.

Stock agency sample contract (FoodPix Content Partner Agreement) on pages 47–51. Courtesy of FoodPix, Culver City, CA. Used by permission.

Portfolio photos on pages 71–72. Copyright Light Impressions, Corp., P.O. Box 940, 439 Monroe Ave., Rochester, NY 14603-0940. Call (800) 828-6216 to request a free catalog or place an order. Used by permission.

Photos on pages 81–91. Copyright of Sam Marshall, Cincinnati, OH. Used by permission.

DEDICATION

To my family, Dick, Barb, Phil, David and Colette, for your unyielding support through the best and worst of times. And to Jenny, Alex and Marley, for reminding me daily that love is a limitless gift to be nurtured, shared and savored.

ACKNOWLEDGMENTS

My sincere thanks to Bill for having enough faith in me to hand me this project. Also, thanks to my editors, Dave and Sam, for guiding this book into its present form. I'm also deeply indebted to several friends and colleagues who guide my creative energy every day. Mark, Joe, Jack, Adam, Joe, the Writer's Digest Market Books staff—all of you, in one way or another, have helped show me what's possible.

ABOUT THE AUTHOR

Michael Willins previously edited *Photographer's Market* for six years. He is a former newspaper reporter/photographer from southeastern Indiana who earned several writing and photography awards from the Hoosier State Press Association. He has written for various trade magazines, including *HOW* and *Big Picture*, and tackled freelance photo assignments for the Cincinnati Direct Marketing Association, United Telephone Company and Starfish Records. He lives in Cleveland, Ohio, with his wife, Jenny.

CONTENTS

Part Two: The Submission

INTRODUCTION

Before you dive into chapter one of this book, take a moment to answer the following question: "What does it mean to be a successful photographer?" Many photographers assume that success stems from an ability to communicate through quality pictures. However, this is only partially correct. Being successful as a professional photographer means knowing how to organize your daily office tasks. It means understanding important issues such as copyright registration and client liability. It means being financially sound now and in the future. And most of all, it means knowing how to successfully market your photographic skills.

The ultimate goal of this book is to make you more productive and profitable by teaching you how to sell your talent. In order to meet this objective, I've provided a step-by-step approach to organizing your business and marketing your work.

This book is divided into two parts. The first part helps you establish a solid foundation from which you can build your business. In it you'll find sample business forms and tips for maintaining image files. I've also included self-promotion and portfolio ideas, a section on copyright registration and another on gaining professional representation. Essentially you'll find everything you need to organize your business and everyday workload.

Part two puts the ideas of part one into practice. You'll see how to properly package submissions and approach various markets—magazines, book publishers, commercial clients, paper product/gift producers and galleries. If you're uncomfortable with writing business letters for your submissions, there are several sample cover and query letters for your review. There are also samples of specialty forms, such as stock lists, a photographer bio and an artist's statement.

Once you've finished the last chapter, my hope is you'll have a better understanding of how to conduct business in a professional manner, which leads to positive reactions from buyers. But remember that while the samples provide guidance, they are not meant to be merely copied and used. You must take the ideas and fashion forms and letters that suit your specific needs. Only then will you get the most out of this book. Only then will you be truly successful.

In the Office

Chapter 1

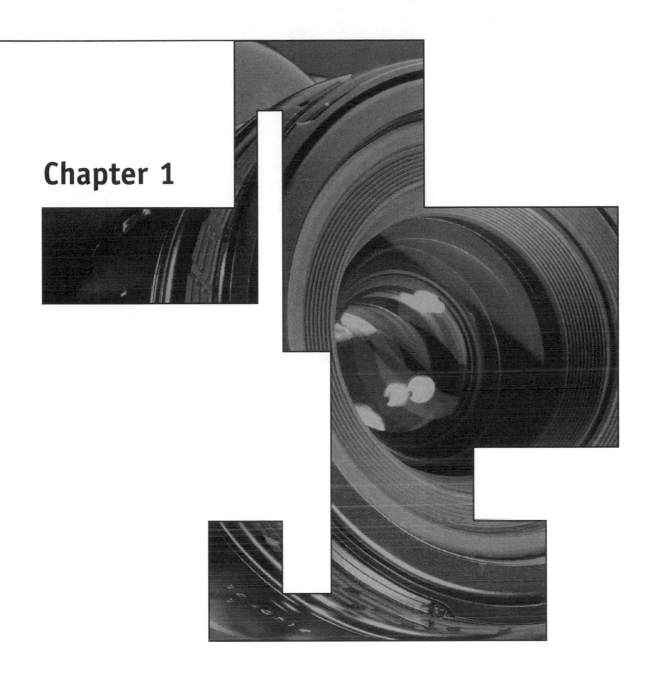

Forms and Formats

As a professional photographer, it's important to have a place where you can conduct business without distractions. This is true whether you're a beginning photographer or an established pro with a large studio. The office is a place to concentrate on tasks including attracting new clients, organizing files, labeling slides/prints, sending out invoices and packaging submissions.

The forms in this chapter are essential to many of the mailings you conduct. They are designed only as examples. When creating *your* forms, consider what works best for your business and adapt these forms to suit your needs.

Establishing a Filing System

Nothing is more frustrating than being unable to locate photos when potential clients call searching for images. Your filing system should simplify the process of quickly locating and submitting images. You also need a system of tracking submissions so you know who has your images, when those images were mailed to clients and who received them, and when the images are due back.

Talk to any professional photographer and you will learn that photo editors, creative directors and art directors habitually hold images for long periods of time. Sometimes this means buyers are deciding which images to use; sometimes buyers are just too busy to return photos. As a photographer, this can be extremely problematic. You don't want to offend potential clients by ordering the return of your images, but you have a business to run. When photo editors hold images with no intention of using them, they keep you from submitting those photos to other editors who might buy them. This is one reason why having a sound filing system is so important. By tracking your submissions, you can follow up with letters or phone calls to retrieve images from uninterested buyers.

In my guidelines for creating a filing system, I'm assuming you have a computer or at least access to one. Although computers are not essential to your business, they can certainly simplify your day-to-day business tasks. Database software, for example, can help you track submissions, create labels and develop mailing lists. You can

use word processing software to create business forms and cover letters. There is software for photo labeling and photo pricing. All of this can make you more efficient when serving clients.

To create a filing system for your images, you will need labels; plastic protectors (archival quality) for transparencies, negatives and prints; and three-ring binders. You must decide how to code images so they will be easy to find when you need them. For example, perhaps you recently photographed a nesting site for a blue heron. Your code might look something like this: 97WB1-OHO. Translated, this means you took the image in 1997; it's a *Wildlife* photograph of *Birds*; and it's the first photo of a bird cataloged in 1997. The *OH* shows the photo was taken in Ohio and the *O* on the end means it is an original slide rather than a duplicate. When you photograph a subject that needs a model release (see Model/Property Releases, page 11), you might want to add *MR* after the final *O*.

It is a good idea when coding images to have an index of the subjects you shoot. That way you won't forget what each letter means. You also want to create a list for cross-referencing slides that could service several different buyers. For instance, a photo of bison in Yellowstone National Park might be of interest not only to photo editors at wildlife magazines but to buyers of travel images.

Once you establish a coding system, label your images. As mentioned earlier, the easiest way to do this is with image captioning software. Writing information by hand, especially onto hundreds of 35mm slides, can be extremely tedious and time consuming. Typed labels are cleaner and offer a professional look.

Along with the file code, each photo mount should contain your copyright notice, which states the year the image was created and gives your name (e.g., © 1997 Michael Willins). Also include a brief explanation of the image contents. Remember, with captioning software it's easy to write extensive descriptions on labels. When labeling slides, however, too much information tends to clutter presentation and may actually be distracting to the viewer. Three or four words should suffice for 35mm. If you want to provide lengthier captions, do so on a separate sheet of paper. Be certain to list slide codes beside each caption.

If you shoot with medium- or large-format cameras, you can either purchase mounts for your images or place the images in plastic sleeves. Attach labels to protective sleeves or mounts when work is mailed to potential clients. When submitting prints, place a label on the back of each photo and make sure it contains your copyright notice, image code and a brief description of each image. You may want to include your address and telephone number as well.

One word of caution: Never submit negatives when approaching potential clients. You risk damaging the negatives or, worse, having them stolen. Most buyers can use a print to generate a suitable image. You can also send contact sheets for a buyer's review.

Storing Your Images

Now that the images are properly labeled, how should they be stored? First, make sure they are kept in a cool, dry location. Moisture can produce mold on your film and slide mounts. If your work isn't correctly stored, moths may eat transparencies. To prevent damage, place 35mm slides in archival-quality plastic slide protectors. Each page holds up to twenty slides and can be stored in a binder. The binder system also works for larger transparencies and negatives. Prints should be kept in plastic pages.

Unless a photo buyer plans to use an image, do not send him an original transparency. If the original gets lost or damaged, you will lose future sales. Instead, have duplicate transparencies made and store them as you would originals. The price of duplicate slides usually ranges from fifteen to eighty cents per image, depending on the number of dupes you need. The cost normally decreases with larger quantities. If you shoot 35mm slides, consider having your duplicates created as larger transparencies (such as 70mm) rather than 35mm slides. It may cost more, but larger images are often more appealing to buyers because subjects are easier to see.

Creating Your Business Forms

Now that your images are in order, it's time to create your business forms. These include business cards, letterhead, delivery memos,

Sample Slide Mount

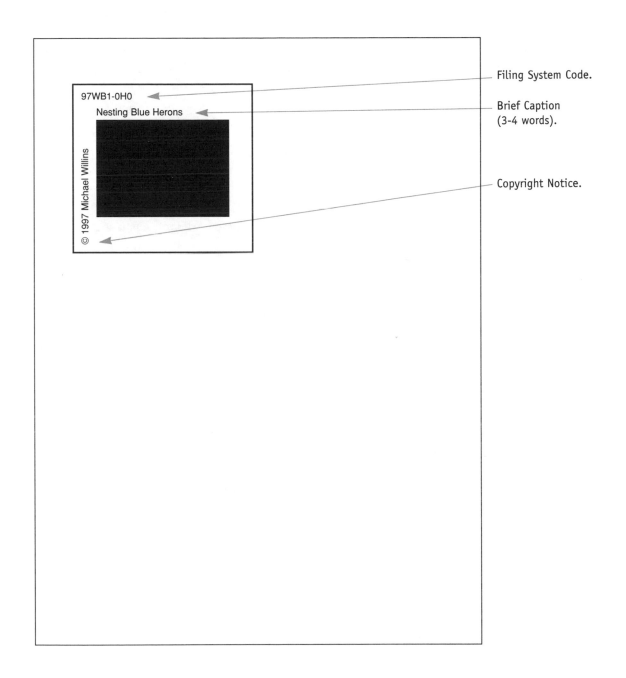

There are several software packages available that simplify the photographer's office workload. I've listed some of my favorites here. The prices vary widely, but then again, so do the systems.

The Norton Slide Captioning System Pro. Produced by photographer Boyd Norton, the NSCS Pro was last updated in January 1997. The software allows you to track submissions, print out forms and stock lists and, of course, write detailed captions. At a cost of $149 (plus shipping and handling), the NSCS Pro is available at P.O. Box 2605, Evergreen, CO 80437-2605, (303) 674-3009.

CRADOC CaptionWriter. Strictly a caption-writing system, this product was originally created in the mid-1980s by Cradoc Bagshaw of Point Roberts, Washington. This software can be used in conjunction with another program, Photo Management System, which gives users extensive database capabilities and allows them to write invoices or delivery memos and print out reports. Cost for each program is $69.95 (plus shipping and handling). Both are distributed by Perfect Niche Software Inc., 6962 E. First Ave., #103, Scottsdale, AZ 85251, (800) 947-7155.

PhotoByte 2000. Developed by Vertex Software owner Tom Zimberoff, this software is used industry wide by people who want heavy-duty assistance for their offices. PhotoByte assists users in daily tasks, such as creation of invoices and bidding estimates, and tracking images or entire portfolios. It even helps users with financial record keeping for accounting purposes. Cost is $995 (plus shipping and handling). Last updated in spring 1997, PhotoByte is available at Vertex Software, 31 Wolfback Ridge Rd., Sausalito, CA 94965, (415) 331-3100.

model/property releases, a standard list of terms and conditions, assignment estimate/confirmation forms and invoices. These forms show professionalism, and some may be necessary for legal disputes.

Business Cards and Letterhead

Picking a style for your business card is simply a matter of preference. Some photographers favor a straightforward appearance—nothing

but the photographer's name, a company name, address, phone and fax numbers, and possibly e-mail address. This method is usually the least expensive. Other photographers like to add a little flair to their cards. They might use bright color card stock, multiple colors for the printing, or have stylish fonts embossed onto the card. Some photographers have photos printed directly on their business cards to showcase their skills to clients. I've even seen one business card that looked like a stick of chewing gum.

Whatever route you take, include current information and, whenever possible, match your business card with your letterhead. If you have a logo, include it on your business card as well as your letterhead. Also consider matching the color of the two pieces. This helps buyers remember you.

As with the business card, the letterhead is a matter of preference. There is computer software for designing impressive-looking letterhead. Adobe PageMaker and QuarkXPress are two that handle this task quite easily. You may consider hiring a designer or working with a printer to create your letterhead. Obviously, this would cost a little more money, but the expense might be worth it to you. Another option is to work out a trade with a designer—your photographic skills on one of her projects in exchange for her design help. For other great ideas on this subject, check out *Fresh Ideas in Letterhead & Business Card Design* (North Light Books).

Delivery Memos

The delivery memo tells clients what images are enclosed in your submission and how the clients can contact you. In the case of assignment work, this form is usually mailed with your images upon completion of each job. However, you may want to mail the delivery memo with stock submissions when a potential client is interested in reviewing your work.

This form is a good way to inform clients about copyright laws and explain liability—outlining what happens if images are lost, damaged, not returned or used without consent. For more on copyright, see chapter five. These legal issues are often covered within a list of

Sample Business Card and Letterhead

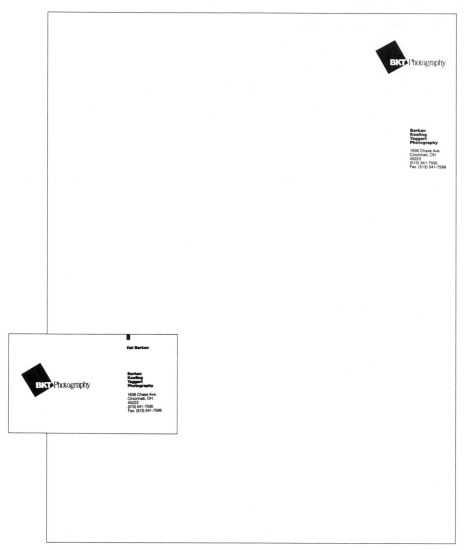

Include business identity logo on all forms. Include phone, fax and address.

terms and conditions placed on the back of the delivery memo (see Terms & Conditions, page 14).

During the review process, some clients might hold images for long periods of time, sometimes several months. Therefore, most photographers like to include two copies of their delivery memos in every submission. The client keeps one copy and signs and returns the second to acknowledge receipt of the submission. This way a client verifies all images listed on a delivery memo are in the package and the photographer verifies the images arrived in good condition. Photographers may also give time limits (anywhere from fourteen to thirty days) for review of their submissions.

Model/Property Releases

The one topic that generates most questions from beginning professional photographers is *releases*—when are they needed and when are they not needed? In all honesty, I believe most newcomers are uncomfortable asking subjects for releases. They don't know how to approach someone about signing a legal document; therefore, they don't ask. This is unfortunate because many clients require releases, and by not having subjects give written consent, photographers lose lots of money on potential sales.

Releases are meant to keep you from infringing on the rights of the person being photographed. The subjects sign the forms to grant you permission to sell photos that contain them or their private property. "Private property" refers to a wide range of subjects, including cattle with noticeable brands, hotels, casinos, homes, even boats with obvious registration numbers.

The rule on releases is this:

When shooting photographs for editorial usage, such as magazines and newspapers, you do not need releases. If you intend to sell them for advertising or corporate usage, you do need releases.

There are exceptions, however. Many magazines, especially those publishing images of nude or seminude models, require releases. Most calendar, greeting card and poster companies also require releases.

Sample Delivery Memo A

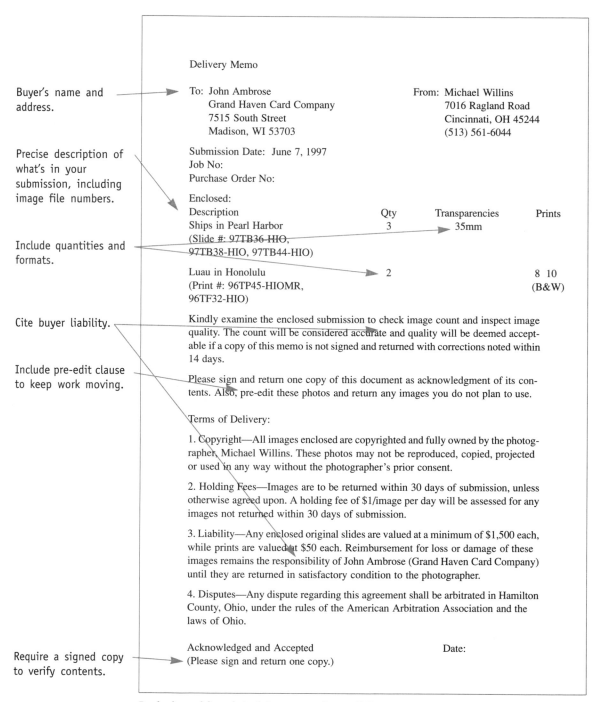

Buyer's name and address.

Precise description of what's in your submission, including image file numbers.

Include quantities and formats.

Cite buyer liability.

Include pre-edit clause to keep work moving.

Require a signed copy to verify contents.

Delivery Memo

To: John Ambrose
 Grand Haven Card Company
 7515 South Street
 Madison, WI 53703

From: Michael Willins
 7016 Ragland Road
 Cincinnati, OH 45244
 (513) 561-6044

Submission Date: June 7, 1997
Job No:
Purchase Order No:

Enclosed:

Description	Qty	Transparencies	Prints
Ships in Pearl Harbor (Slide #: 97TB36-HIO, 97TB38-HIO, 97TB44-HIO)	3	35mm	
Luau in Honolulu (Print #: 96TP45-HIOMR, 96TF32-HIO)	2		8 10 (B&W)

Kindly examine the enclosed submission to check image count and inspect image quality. The count will be considered accurate and quality will be deemed acceptable if a copy of this memo is not signed and returned with corrections noted within 14 days.

Please sign and return one copy of this document as acknowledgment of its contents. Also, pre-edit these photos and return any images you do not plan to use.

Terms of Delivery:

1. Copyright—All images enclosed are copyrighted and fully owned by the photographer, Michael Willins. These photos may not be reproduced, copied, projected or used in any way without the photographer's prior consent.

2. Holding Fees—Images are to be returned within 30 days of submission, unless otherwise agreed upon. A holding fee of $1/image per day will be assessed for any images not returned within 30 days of submission.

3. Liability—Any enclosed original slides are valued at a minimum of $1,500 each, while prints are valued at $50 each. Reimbursement for loss or damage of these images remains the responsibility of John Ambrose (Grand Haven Card Company) until they are returned in satisfactory condition to the photographer.

4. Disputes—Any dispute regarding this agreement shall be arbitrated in Hamilton County, Ohio, under the rules of the American Arbitration Association and the laws of Ohio.

Acknowledged and Accepted Date:
(Please sign and return one copy.)

Includes abbreviated terms and conditions.

Sample Delivery Memo B

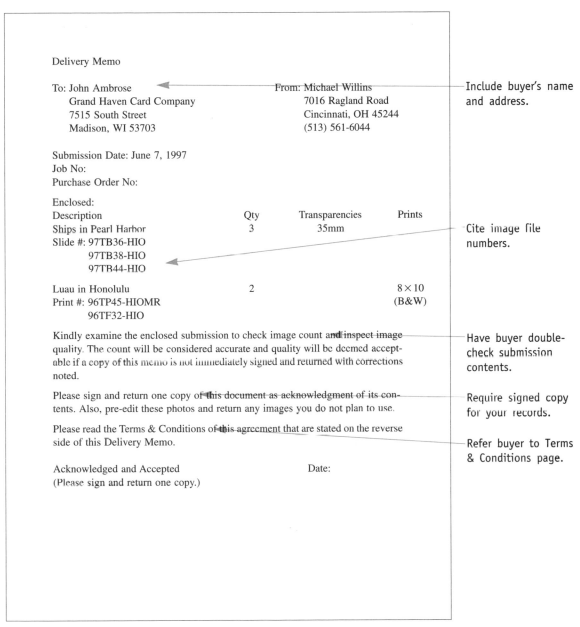

Delivery Memo

To: John Ambrose From: Michael Willins —Include buyer's name
 Grand Haven Card Company 7016 Ragland Road and address.
 7515 South Street Cincinnati, OH 45244
 Madison, WI 53703 (513) 561-6044

Submission Date: June 7, 1997
Job No:
Purchase Order No:

Enclosed:
Description Qty Transparencies Prints
Ships in Pearl Harbor 3 35mm —Cite image file
Slide #: 97TB36-HIO numbers.
 97TB38-HIO
 97TB44-HIO

Luau in Honolulu 2 8 × 10
Print #: 96TP45-HIOMR (B&W)
 96TF32-HIO

Kindly examine the enclosed submission to check image count and inspect image —Have buyer double-
quality. The count will be considered accurate and quality will be deemed accept- check submission
able if a copy of this memo is not immediately signed and returned with corrections contents.
noted.

Please sign and return one copy of this document as acknowledgment of its con- —Require signed copy
tents. Also, pre-edit these photos and return any images you do not plan to use. for your records.

Please read the Terms & Conditions of this agreement that are stated on the reverse —Refer buyer to Terms
side of this Delivery Memo. & Conditions page.

Acknowledged and Accepted Date:
(Please sign and return one copy.)

Does not include terms and conditions.

The best advice is to always get a signed release. Having releases increases the sales potential for all your work. You never know when an advertising client is going to request an image he spotted in a magazine. Also, by acquiring releases you will protect yourself against legal action. And most importantly, in the case of minors, remember to have parents or guardians sign the releases.

It's not uncommon for photographers to offer prints in exchange for a signed release. Friends who serve as models usually enjoy the experience and a nice 8×10 makes a good "Thank you." The same is true for strangers, who are often flattered you took their picture. If someone asks for monetary payment, decide what it's worth to you and negotiate. Whatever you do, don't get into a situation where you agree to pay based on image sales. This is an accounting nightmare. Plus, what happens if the image doesn't sell for a couple years and when it does you find out the model has moved? If she's a stranger in another city, how are you going to find her? It's not worth the headache.

There are times when you must hire professional models, and in those instances, make sure you keep track of all related expenses. When you negotiate image sales, try to recover your modeling fees by increasing your bottom-line price. You don't want to lose money every time you hire a model for a shoot.

One final note: When traveling in a foreign country, carry a release that has been translated into the native language. This will eliminate any confusion due to language barriers. Staff members at foreign embassies and students and professors at colleges and universities can help you with translations. If you have access to online services, see if chat groups can help.

Terms & Conditions

A list of terms and conditions is often mailed to clients on the back of other forms (such as delivery memos or estimates/confirmations). The terms and conditions statements are usually written in legalese, and they protect you from misuse or abuse of your images. These terms spell out your responsibility to clients and the responsibility of clients to you. Because this is such an important document, it's

Sample Model Release

Model Release

I hereby grant [photographer], his/her legal representatives and assigns (including any agency, client or publication) irrevocable permission to publish photographs of me, taken at _____. These images may be published in any manner, including advertising, periodicals, greeting cards and calendars. Furthermore, I will hold harmless aforementioned photographer, his/her representatives and assigns from any liability by virtue of any blurring, distortion or alteration that may occur in producing the finished product, unless it can be proven that such blurring, distortion or alteration was done with malicious intent toward me.

I affirm that I am more than 18 years of age and competent to sign this contract on my own behalf. I have read this release and fully understand its contents.

Please Print:
Model's Name _____
Address _____
City _____ State _____ Zip Code _____
Country _____

Model's Signature _____
Witness _____ Date _____

Parent/Guardian Consent (if applicable):
I am the parent or guardian of the minor named above and have legal authority to execute this release. I consent to use of said photographs based on the contents of this release.

Parent/Guardian Name _____
Parent/Guardian Signature _____
Witness _____ Date _____

— Location of shoot.

— Protection against liability.

— Model's name and address.

— Signatures of model and witness.

— Parent/Guardian consent for minors.

Sample Property Release

Property Release

For valuable consideration herein as received, the undersigned, being the legal owner of or having the right to permit the taking and use of photographs of certain ~~property designated as~~ _____, does grant to [photographer], his/her legal representatives and assigns (including any agency, client or publication) irrevocable permission to publish these photographs in any manner.

Property description.

I hereby relinquish any right that I may have to examine or approve the completed product(s) or the advertising copy or printed material that may be used in conjunction therewith or the use to which it may be applied.

Protection against liability.

I hereby release, discharge and agree to hold harmless [photographer], his/her heirs, legal representatives or assigns, and all persons functioning under his/her permission or authority, or those for whom he/she is functioning, from any liability by virtue of any blurring, distortion or alteration that may occur in producing the finished product, as well as any publication thereof, including any claims for libel or invasion of privacy.

I affirm that I am of full age and competent to sign this contract on my own behalf. I have read this release and fully understand its contents.

Property owner's address and signature.

Please Print:
Name _____
Address _____
City _____ State _____ Zip Code _____
Country _____

Signature _____
Witness _____ Date _____

best to work with an attorney on the appropriate language.

It's important you understand the reasoning behind some of the key language. The sample on pages 19-20 is meant to provide ideas and should be adjusted based on what's important to you as a businessperson. You can cover as much as you wish, but there are a few key points that should definitely be included in your terms and conditions.

Protect against copyright infringement. Too many clients, and unfortunately photographers, do not understand what copyright is all about. Some clients believe that once they purchase images to use, they own those images and, therefore, can use them whenever and wherever they like. Nothing could be further from the truth.

When a person buys an image, he is buying the right to use that image in a specific way. He is not allowed to use that image indefinitely without your permission. Your terms and conditions must spell out the rights you are giving a client. Start with one-time usage rights and negotiate from there. Also, insist on having your photo credit appear with the printed work. For more on copyright, see chapter five.

Protect against image alteration. Digital technology is simplifying the process of image manipulation, making it even more important to protect yourself against misuse and theft of your work. To do this, add a clause in your terms and conditions that discusses image alterations and computer storage of your work. If a client plans to make radical changes to your images, stipulate that those alterations must meet with your approval.

Don't let clients keep digital files of your images. Specify that any digital files of your work should be deleted once your images are published. People change jobs, and the next person using a client's computer may find your work and unknowingly think it's fair game for other projects.

Clarify liability for lost or damaged images. Clients must understand image value. If transparencies are lost or damaged, you lose future sales, and clients need to know that fact. Make sure they know to

inspect the images when they arrive. If damage has occurred in shipping, clients must notify you immediately. Once they sign and return your delivery memos, they are responsible for the well-being of your images.

This is one reason why sending submissions via certified mail is important. Someone must sign for such packages, so clients can't say your photos never arrived.

Tracking Submissions

One of the most important aspects of stock photography is knowing which companies have your photos, when you mailed submissions and when they are due back. If you have images in the hands of clients who have no intention of using them, you're losing sales to other buyers who can use them. That's why it's so important to have a sound labeling, filing and tracking system for your photographs.

A tracking chart like the one on page 21 will enable you to organize your submissions and keep up with client needs. This chart works well on paper, but database software can be an ideal way to keep submission records. Using this chart as an example, in which the titles are field names, a database would allow you to group clients by specialties or deadlines. You also could sort each client by the date of your next contact, which can be extremely helpful when organizing your mailing schedule for promotional materials or spec submissions.

Assignment Estimate/Confirmation

When clients hire you to complete assignments, or even if they are merely considering hiring you, supply them with assignment estimate/confirmation forms. As with the delivery memo, this form is usually mailed with a list of terms and conditions.

As an estimate, this document breaks down your expenses for a client and shows what the assignment will cost. It lists everything possible—modeling fees, props, creative fees, any expenses for equipment rental or assistants, travel expenses, etc. It spells out the image rights a client is purchasing and contains an overall description of

Sample Terms & Conditions

Terms & Conditions

1. Delivery and Definition. Photographer has delivered to the Client those Photographs listed on the front of this form. "Photographs" are defined to include transparencies, prints, negatives, digitized encodations and any other form in which the images submitted can be stored, incorporated, represented, projected or perceived, including forms and processes not presently in existence but that may come into being in the future.

2. Grant of Rights. Upon receipt of full payment, Photographer shall license to the Client the rights set forth on the front of this form for the listed Photographs.

3. Reservation of Rights. All rights not expressly granted are reserved to the Photographer. Without limiting the foregoing, no advertising or promotional usage whatsoever may be made of any Photographs unless such advertising or promotional usage is expressly permitted on the front of this form. Limitations on usage shown on the front of this form include but are not limited to size, placement and whether usage is in black and white or color.

Copyright remains with photographer unless otherwise expressed.

4. Fee. Client shall pay the fee shown on the front of this form for the usage rights granted. Client shall also pay sales tax, if required.

5. Payment. Payment is due to the Photographer within 30 days of the date of this Invoice. Overdue payments shall be subject to interest charges of _____ percent monthly. Time is of the essence with respect to payment.

Overdue charges for late payment.

6. Copyright Notice. Copyright notice in the name of the Photographer shall be adjacent to the Photographs when reproduced unless otherwise agreed by both parties and stated in this Invoice. If such copyright notice, which also serves as authorship credit, is required hereunder but is omitted, the Client shall pay as liquidated damages triple the usage fee agreed to between the parties instead of the agreed upon usage fee. Copyright credit must be as shown on the Photographs unless specified to the contrary by the Photographer.

Require photo credit.

7. Alterations. Client shall not make alterations, additions or deletions to the Photographs, including but not limited to the making of derivative or composite images by the use of computers or other means, without the express, written consent of the Photographer. This prohibition shall include processes not presently in existence but that may come into being in the future.

Limit image alteration.

8. Loss, Theft or Damage. The ownership of the Photographs shall remain with the Photographer. Client agrees to assume full responsibility and be strictly liable as an Insurer for loss, theft or damage to the Photographs and to insure the Photographs fully from the time of shipment from the Photographer to the Client until the time of return receipt by the Photographer. Client further agrees to return all of the Photographs at its own expense by registered mail or bonded courier that provides proof of receipt. Reimbursement for loss, theft or damage to any Photograph shall be in the amount of the value entered for that Photograph on the front of this form. Both Client and Photographer agree that the specified values represent the fair and reasonable values of the Photographs. Unless the value for an original transparency is specified otherwise on the front of this form, both parties agree that each original transparency has a fair and reasonable value of $1,500 (Fifteen Hundred Dollars). Client agrees to reimburse Photographer for these fair and reasonable values in event of loss, theft or damage.

Client liability.

Fee for damaged or lost images.

Sample Terms & Conditions continued on page 20.

9. Tearsheets. Client shall provide Photographer with two (2) copies of tearsheets of any authorized usage.

10. Releases. Client agrees to indemnify and hold harmless the Photographer against any and all claims, costs and expenses, including attorney's fees, arising when no model or property release has been provided to the Client by the Photographer or when the uses exceed the uses allowed pursuant to such a release.

11. Arbitration. All disputes shall be submitted to binding arbitration before _____ in the following location _____ and settled in accordance with the rules of the American Arbitration Association. Judgment upon the arbitration award may be entered in any court having jurisdiction thereof. Disputes in which the amount at issue is less than $ _____ shall not be subject to this arbitration provision.

12. Assignment. Neither party shall transfer or assign any rights or obligations hereunder without the consent of the other party, except that the Photographer shall have the right to assign monies due.

13. Miscellany. This Agreement shall be binding upon the parties hereto, their heirs, successors, assigns and personal representatives. This Agreement constitutes the full understanding between the parties hereto. Its terms may only be modified by a written instrument signed by both parties. A waiver of a breach of any of the provisions of this Agreement shall not be construed as a continuing waiver of other breaches of the same or other provisions hereof. This Agreement shall be governed by the laws of the State of _____.

Courtesy of Rob Buenning, Overland Park, Kansas.

the job. Once you are hired, this becomes a confirmation form that gets signed and returned to you by the client.

The importance of this form is twofold. First, there is good communication between you and the client about the assignment. Both of you know what's expected and the deadlines to be met. Second, the client is made aware of fees and usage rights—what she can and cannot do with images.

As you create this form, remember you are essentially bidding for a job. You want to provide an accurate estimate that is fair to you and the client, but also to fellow photographers. Don't "lowball" an assignment by saying you can do a job for less in order to beat out the competition. This brings down prices throughout the photo industry because clients learn they can shop around for ridiculously low prices.

Note: It's essential to know your value and the actual cost of your assignment. You are in business to make a profit, so avoid any situations where you lose money on an assignment by underestimating

Sample Submission Tracking Chart

Submission Tracking Chart

Company: _____ Specialty: _____

Address: _____ _____
_____ _____
_____ _____

Phone: _____ _____
Fax: _____ _____
E-mail: _____ _____
Contact: _____ _____
Title: _____ _____

Seasonal Needs: _____ Deadlines: _____
_____ _____
_____ _____

Last Contact Next Contact
Date: _____ Date 2: _____
Notes: _____ Notes 2: _____
_____ _____
_____ _____
_____ _____
_____ _____
_____ _____

Addnl Notes: _____

Include subjects the client specializes in.

Keep this information current.

Cite regular deadlines for clients.

Be certain to follow up.

This area may include any information that better helps you understand the market.

This form works well in database software because of the information-sorting capabilities.

the expenses. Keep track of clients' changes, such as new concepts that alter the time necessary to complete the assignments. These adjustments are not your fault, and you should not expect to be bound by original estimates. Have clients initial or sign changes immediately so these additional expenses can be added to your original estimates. Don't wait until after projects are completed to discuss new costs. This only creates animosity between you and your clients.

Invoices

This is the form everyone wants to send. It's the one that says, "Thanks for using my work. Here's what you owe me." You'll need to establish a numbering system for your invoices so you know which bills have been paid and which have not. This is extremely important come tax time. There is no need to have a complicated system. Simply include the year and start numbering from one (e.g., 970001).

Make sure your invoice contains your name, address, telephone number and either your social security number or your business tax identification number. Without a social security or tax identification number for tax purposes, your invoice won't get processed.

Often, clients hold payment until an invoice is received. So be sure to send one as soon as the deal is closed. Some clients will pay once images are published; others will pay once they agree to use your images. Know how each client operates. If payment is not going to be sent for several months, or even a year, you must know this. Otherwise, bills and other expenses can drive you out of business while you wait for payment to arrive.

A word of advice here: Don't threaten lawsuits every time a client is late with payment. You don't want to alienate clients by assuming they are cheating you. Maybe the accounting department failed to process your invoice, or maybe there was a delay in printing. If payment is late, start with a tactful follow-up phone call and immediately send a brief letter recapping your conversation. State your understanding of when payment should arrive, and remember to thank the client for the business. If this doesn't get results, send a certified letter with a new date of payment and stipulate that late fees will be assessed. Spell out those fees. If still no response, consider legal action.

Sample Assignment Estimate/ Confirmation

Assignment Estimate/Confirmation

To: Mark Garvey From: Michael Willins — **Buyer's name and address.**
Living With Nature Magazine 7016 Ragland Road
321 Leopard Lane Cincinnati, OH 45244
Boston, MA 02134 (513) 561-6044
 SS#: 555-55-5555 — **Include social security number or tax ID number for tax purposes.**

Date:	September 5, 1997
Job #:	97LWN9-36
Assignment:	The Wolves of Yellowstone
Client:	*Living With Nature Magazine*

Assignment Description: Photographing Wolves in Yellowstone National Park. A study of how they are surviving since their reintroduction to the park.

Rights Granted and Usage Period: *Living With Nature* will receive First Exclusive Rights to images. Exclusive Rights are issued for published photos only for a period of six months after first publication of photos. Once the six-month period expires, all rights to all photos revert back to the Photographer.

— Rights granted with time limitation.

Expenses:

Travel	$ 375
Transportation	$ 125
Meals	$ 80
Lodging	$ 150
Telephone	$ 20
Usage Fees and Space Rates	$2,000
Shipping Fees	$ 50
Site Permits	$ 50
Assistants @ _____/day	n/a
Photography @ $400/day	$1,600
Film/Processing	$ 325
Equipment Rentals	n/a
Miscellaneous	$ 75
Total:	$4,850

— Detailed list of expenses.

Acknowledged and Accepted: _____ Date: _____

— Client signature.

(Please sign and return one copy.)

Please read the terms and conditions listed on the reverse side of this form. Unless otherwise agreed upon in writing, the photographer retains all rights to photographs taken during this assignment. Additional usage of these photographs will require negotiation of additional fees. Payment of invoice will be due within 30 days of receipt of invoice.

— Direct buyer to terms and conditions page.

Sample Invoice

Invoice

To: Bret Seigel From: Michael Willins
 All About Cars Magazine 7016 Ragland Road
 777 Tread Avenue Cincinnati, OH 45244
 New York, NY 10011 (513) 561-6044
 SS#: 555-55-5555

Date: April 24, 1997
Invoice #: 97AACARS4-23
Assignment: Custom Car Show in Cincinnati
Client: *All About Cars Magazine*

Description:
Coverage of the 1997 Custom Car Show in Cincinnati
 —Color Cover Shot for *All About Cars Magazine*
 —Two ½-page color shots of convention attendees for inside usage

Expenses:

Travel	n/a
Transportation	$ 13
Meals	$ 47
Assistants	$250
Creative Fee	$850
Film/Processing	$ 85
Site Permits	$ 20
Equipment Rentals	n/a
Lodging	n/a
Telephone	$ 6.75
Miscellaneous	$ 26.50

Due Date: May 24, 1997 Total Due: $1,298.25

Payment will be considered late if not received within 30 days of this invoice date. A fee of $10/day may be assessed if payment is not received by the due date listed above.

Annotations (left margin):

Include social security number or tax ID number for tax purposes.

Cite invoice number for filing purposes.

Description of assignment.

Cite payment deadline.

Total amount due.

Include late fee clause.

Chapter 2

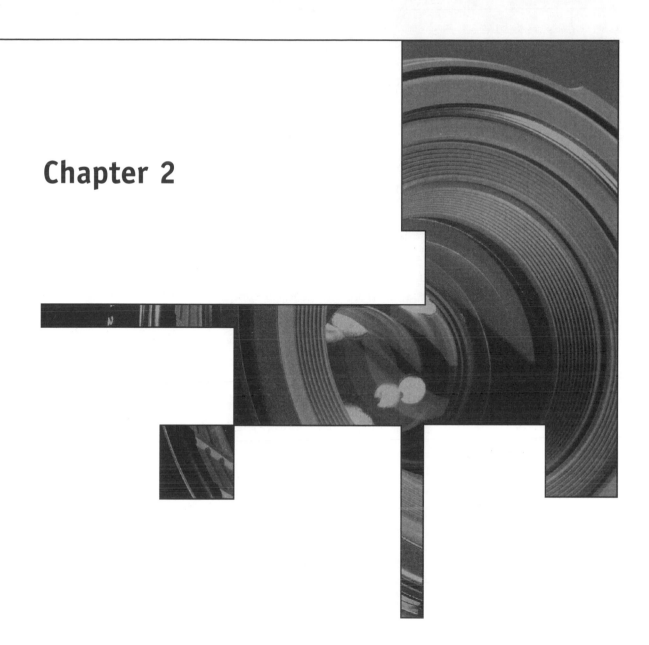

Self-Promotion

For many photographers, the idea of "selling themselves" ranks right up there with a triple-bypass heart operation. Selling is necessary, but the concept is scary as hell.

Take a deep breath and relax. Selling yourself doesn't have to be frightening. The concept to remember is a simple one: Concentrate on your strengths and ignore your weaknesses. It's human nature to fear rejection, and, therefore, we dwell on negatives and perpetuate self-doubt. This keeps many people from succeeding. However, your work is valuable, otherwise you wouldn't be interested in selling it. Never forget that, and don't let potential clients forget that either.

I've seen work from hundreds of photographers, and often there is little difference in technical skill level. They all understand how to position subjects; they know about composition and proper lighting. However, what many of them don't understand is how to promote those skills.

Successful photographers work just as hard on self-promotion as they do their photography. Some experts estimate a photographer should spend about 10 to 15 percent of projected gross sales on self-promotion. If you expect to make $50,000 in total sales for a year, plan on spending $5,000 to $7,500 to market yourself. This may seem like a lot, but the return on the investment is worth the expense.

The ideal self-promotion should showcase your creativity, keep your name fresh in the minds of potential buyers and generate new business for you. As a photographer, you have an ability to view things differently than most people. Don't abandon those skills when developing promotional pieces. Some ideas may seem completely wacky, but try them anyway. There's no difference between experimenting with a new photographic technique and experimenting with new self-promotion ideas; if those methods bring in clients, who cares if the concepts seem off-the-wall?

It's impossible to list every successful self-promotion idea that has ever taken place. However, there are a few key concepts to grasp that can help you attract clients:

- **Provide buyers with promotional pieces they can use every day.** This will give you name recognition when assignments arise.

For example, rather than having a standard business card, consider printing one that functions as a bookmark. How about giving away calendars that contain your photos? When buyers use these items, they will see your name over and over again.

• **Target your potential markets.** Mass mailings will help you reach lots of potential clients, but the most effective mailers are those that respond to buyer needs. If, for example, you want to work with a computer company, send samples of images that showcase computer equipment. Down the road that company may have a new product it needs to advertise and your style might be perfect for the job.

• **Make your promotional piece stand out.** Picture editors receive dozens of mailers every month. You want a buyer to look at your piece and think, *Wow, this person is really creative.*

Making Use of Postcards and Tearsheets

An easy and fairly inexpensive way to market yourself is by mailing a postcard or tearsheet that contains one of your best images, preferably something that's indicative of your style. Such pieces don't have to be real elaborate and won't cost you much money. A photo finishing lab should be able to print five hundred postcards for less than fifty dollars.

Postcards should be designed the way you like them. You might place a photo on one side and your name, address, phone, area of expertise and a client list on the other. You might want your name, address and phone number placed in a white border around the image, saving the back for a brief, handwritten note. Whatever you decide, the piece should be professional looking and keep buyers interested.

When your images are published, ask buyers to provide you with tearsheets so you can show them to prospective clients. More often than not, clients will oblige. It's usually best to package tearsheets in plastic sleeves and surround them with cardboard so they don't crease. If you only have a small number of tearsheets, ask buyers to return

them when they are finished reviewing your work. However, it's best if clients can hold onto tearsheets so they are constantly reminded of you.

The other bonus about postcards and tearsheets is that art directors love them. I've spoken to many art directors who hate getting unsolicited work in the mail. They don't want the liability of holding someone else's work, and they don't want to deal with the hassle of sending work back. They'd much rather have something to file away or hang on a wall for future reference. Postcards and tearsheets are perfect for this task. They give buyers a quick indication of your photographic style and skill level.

One quick note: Don't get discouraged if you don't hear from an art director two weeks after you've mailed a submission. As mentioned, many art directors hang postcards and tearsheets on their walls and refer to them when assignments come up. It may be months before they contact you. Just keep working and consider sending follow-up mailings every three or four months.

Writing a Press Release

The idea behind a press release is to grab an editor's attention so he is interested in sharing your story with readers. In sharing your story, an editor increases your name recognition among readers and, hopefully, attracts more business for you.

The press release itself does not have to be very long. A few paragraphs are all you need, especially if you're uncomfortable with writing. The important thing is to be straightforward and tell the essential elements of your story. If you earned an award, make sure your release tells why you received the honor and who gave it to you. When did you receive the award and where? If you cover the five Ws and the H—Who, What, Where, When, Why and How—you'll stick to the basics of your story without missing any important information.

You also want a press release that's timely, especially when dealing with newspapers, TV media or weekly magazines. Don't procrastinate! Write your release as soon as possible. If the press release is about an event that is going to take place, such as an award

Sample Tearsheet

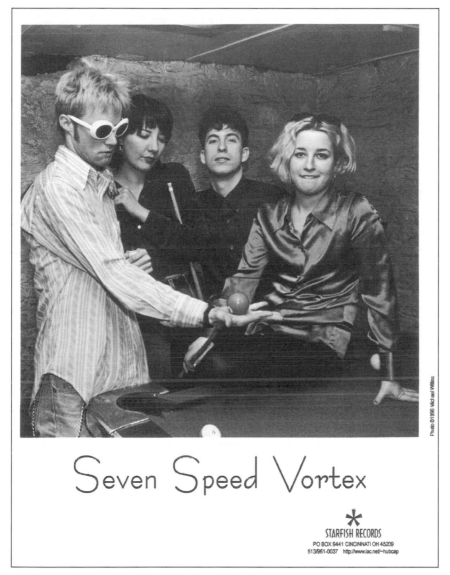

Photo ©1996 Michael Wilkins

Whenever possible get a credit line for your published work.

Seven Speed Vortex

STARFISH RECORDS
PO BOX 9441 CINCINNATI OH 45209
513/961-0037 http://www.iac.net/~hubcap

Ask clients to provide you with tearsheets when your work is used. Promo cards like this one are a great way to show new clients you have a track record.

presentation, editors can plan for coverage if they are notified in advance. Telling them after the fact limits your chance for additional coverage.

If you are not a writer, find someone to read your release before you mail it out. Have the person check spelling and grammar to make sure the article makes sense. An article laden with typos and grammatical errors could turn editors off to your story. You want to make it easy for them to share your story with readers. The more they have to edit, the less they will want to use it.

Remember that it doesn't matter whether the article you wrote is printed verbatim by a magazine or newspaper. Many editors use press releases as leads for stories. They may not like your lead and change it, or they may want to expand the story by calling you and asking a few more questions. They may contact other parties listed in the release for additional information. Whatever the circumstances, the most important thing is for your name to get printed or mentioned. How that happens really doesn't matter.

Another way of getting an editor's attention is by adding photographs to your release. A head shot of yourself, tucked inside a press release with a few of your images, might make the difference. After all, you want to promote your photographic talent. And editors often prefer text-photo packages.

Finally, don't feel uncomfortable about publicizing yourself. You're in business to make money, and getting your name in the papers, or on radio or TV, is the best way for you to be successful. Don't consider press releases to be too pushy or egotistical. Your main concern is to build name recognition so photo buyers consider you for projects. If they haven't heard of you, chances are they won't hire you.

Advertising Your Services

Advertising can be done in many different ways: magazines and sourcebooks, through direct-mail pieces, on billboards, radio, television, or even over the Internet. If there is a form of media that reaches your audience, consider advertising in it to generate business for yourself. It all depends on the amount of money you want to spend.

WHAT ITEMS ARE WORTHY OF A PRESS RELEASE?

- Awards you've won
- Relocation or opening of your business
- Expansion of your services
- Acquisition of top-notch clients
- Completion of big projects
- Speaking engagements
- Completion of pro bono work for various causes
- Digital ventures, such as your new CD-ROM or web site

Before starting this process, think about whom you want to reach. For example, if you are a food photographer, it's pointless to advertise in a magazine for hot-air balloon enthusiasts. Instead, consider placing ads in magazines that are read by people in the food industry—restaurateurs, chefs, beer and wine distributors.

If you're considering advertising, acquire media kits whenever possible to learn which outlets will benefit you most. Usually, these kits are easy to obtain from magazines by contacting their ad sales departments. Media kits provide demographics that can help you decide if the audience is worth contacting. You can locate statistics such as the percentage of male and female readers of a magazine, their ages, average incomes and hobbies. Media kits also provide ad sizes and rates.

Always track the results of each ad you place so you know which ones are working for you and which ones waste your money. When clients come calling, ask how they found out about you. Then concentrate your efforts on the proven methods. The more you can precisely target your efforts, the greater your chances for success.

Electronic Presentation

As digital technology becomes more common in the business world, opportunities will increase for electronic presentation of photos. Five years ago magazine picture editors rarely used computer disks, CD-ROMs or the Internet to gather photos for their projects. Now these

Sample Press Release

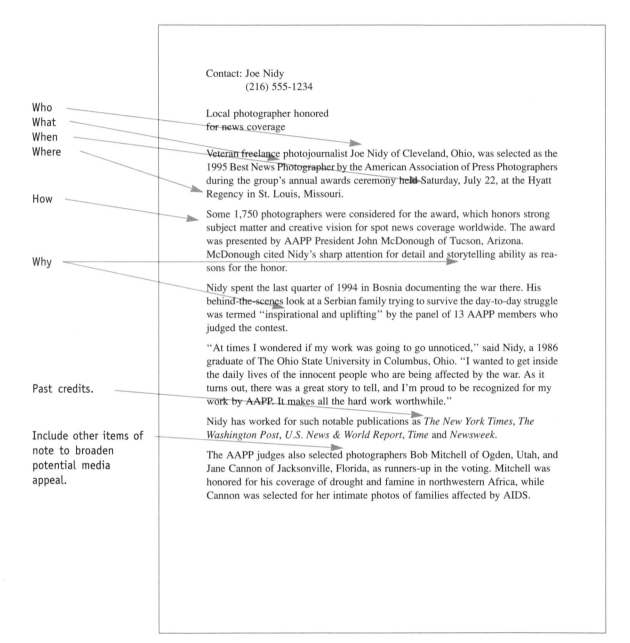

Who
What
When
Where

How

Why

Past credits.

Include other items of note to broaden potential media appeal.

Contact: Joe Nidy
(216) 555-1234

Local photographer honored
for news coverage

Veteran freelance photojournalist Joe Nidy of Cleveland, Ohio, was selected as the 1995 Best News Photographer by the American Association of Press Photographers during the group's annual awards ceremony held Saturday, July 22, at the Hyatt Regency in St. Louis, Missouri.

Some 1,750 photographers were considered for the award, which honors strong subject matter and creative vision for spot news coverage worldwide. The award was presented by AAPP President John McDonough of Tucson, Arizona. McDonough cited Nidy's sharp attention for detail and storytelling ability as reasons for the honor.

Nidy spent the last quarter of 1994 in Bosnia documenting the war there. His behind-the-scenes look at a Serbian family trying to survive the day-to-day struggle was termed "inspirational and uplifting" by the panel of 13 AAPP members who judged the contest.

"At times I wondered if my work was going to go unnoticed," said Nidy, a 1986 graduate of The Ohio State University in Columbus, Ohio. "I wanted to get inside the daily lives of the innocent people who are being affected by the war. As it turns out, there was a great story to tell, and I'm proud to be recognized for my work by AAPP. It makes all the hard work worthwhile."

Nidy has worked for such notable publications as *The New York Times*, *The Washington Post*, *U.S. News & World Report*, *Time* and *Newsweek*.

The AAPP judges also selected photographers Bob Mitchell of Ogden, Utah, and Jane Cannon of Jacksonville, Florida, as runners-up in the voting. Mitchell was honored for his coverage of drought and famine in northwestern Africa, while Cannon was selected for her intimate photos of families affected by AIDS.

SPLITTING COSTS WITH OTHERS

It's quite possible that other professionals, such as designers, printers, artists or writers, might be interested in collaborating on promotional pieces. A printer, for instance, might be interested in splitting the costs of a calendar with you so he can show the capabilities of new printing equipment. A designer might be willing to waive some design fees in exchange for your photographic skills on a future project. There are many ways to cut costs through negotiation, so keep your eyes open for such opportunities.

tools are common, viable ways of presenting and transporting images to clients. There are, however, some points to consider if you are interested in presenting your images digitally:

• Make sure your CD-ROM can be read by Macintosh and IBM-compatible computers.

• Let buyers know you have the capability to provide digital imagery, and give them your web site address so they can view your work. This may give you an edge with some clients.

• Not all photo buyers have Internet access or the ability to view CD-ROMs. Before you send buyers CD-ROMs they can't use, check to see if they are willing to receive work in this manner. Some buyers, even if they have the ability to view such submissions, don't like CD-ROMs. They believe traditional methods are easier and faster.

• If you're considering online presentation of your portfolio, make sure you connect with a site that buyers often frequent. That is the only way you are going to get much business from this type of promotion. It's impractical to assume that numerous buyers will happen upon your work over the Internet, like what they see and contact you for assignments. There's just too much information on the Internet for this to happen.

Pro Bono Opportunities

Another way to promote yourself is by donating your skills to help a charity or some nonprofit organization. This falls under the category of pro bono work. You won't get paid, but you will benefit from the exposure such projects generate. Plus, you will get the chance to supply great work to worthwhile causes.

Often pro bono work is the place where deals can be struck. In exchange for your time and photographs, the recipient of your generosity might, for example, supply you with one hundred samples of the final product. These samples could then be used in your promotional mailers to attract clients. Perhaps your name could be prominently mentioned in an event program, during a speech or on the finished product.

The sidebar on page 33 mentions sharing costs for projects with other freelancers, and pro bono work is a great place for this type of joint venture. This will keep your expenses down, and all of you will reap the rewards.

Chapter 3

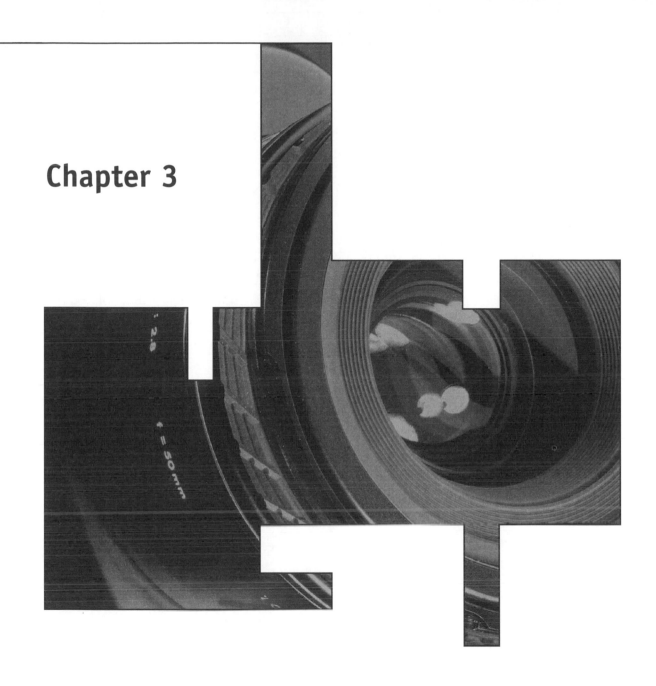

Pricing and Negotiating

I remember a college communications class where I wrote a speech on something I valued. I chose my alarm clock. Not being a morning person, it was important my alarm clock was perfect. It had to wake me without jarring me out of bed. When it sounded every morning, I didn't want it to blast loud rock music. It couldn't screech with a high pitch that shattered glass. I just wanted it to simply beep, softly, so I could slowly open my eyes and adjust to the day. I would have paid anything for it. To me, that's value.

As a professional photographer, it's important to understand the meaning of value to your clients. This is one key to pricing your images. Clients will pay almost anything for images that solve their problems. Likewise, they will pay extra to work with good photographers—those who can provide quality photos on time without any headaches. When negotiating with clients, educate yourself about clients' needs so you know how important your work is to their success. Remember, *the greater their dependency on you, the higher the price should be for your images.*

This chapter discusses value, along with other vital aspects of negotiating fair prices. You'll learn how to compose a business plan. You'll discover the importance of establishing a fee based on usage. And, by the end of this chapter, you'll know how to properly bid projects for clients.

Building a Business Plan

It's important for you to know what it costs to conduct business every day. This includes expenses for everything, from cameras, tripods and lighting equipment, to paper clips and other office supplies. Without knowing this information, you may find yourself undercharging clients. Your expenses will be greater than your income, and eventually you'll be out of business.

The best way to safeguard against financial ruin is to create a business plan. In this document you will account for your annual overhead expenses. (This does not include fees for film, processing, travel expenses or other expenditures that can be passed on to clients.) By knowing your overhead expenses you will know what it costs to

open your doors each day. The following is a list of overhead expenses to account for in your business plan. Note that this list includes an expense for your salary. It's important to pay yourself based on the lifestyle you plan to keep.

- Studio rent or mortgage payment

- Utilities

- Insurance (for liability and your equipment)

- Equipment expenses

- Office supplies

- Postage

- Dues for professional organizations

- Workshop/seminar fees

- Self-promotion/advertising (such as sourcebook ads and direct-mail pieces)

- Fees for professional services (such as lawyers and accountants)

- Equipment depreciation

- Salary expenses for yourself, assistants and office help (including benefits and taxes)

- Other miscellaneous expenses

Once you know your overhead expenses, estimate the number of assignments and sales you will have each year. In order to do this you will need to know how many weeks in the year are actually "billable weeks." Assume that one day a week will be spent conducting office business and marketing your work. This amounts to approximately 10 weeks. Add in days for vacation and sick time, perhaps 3 weeks, and add another week for workshops or seminars. This totals 14 weeks of nonbillable time and 38 billable weeks throughout the year.

Now estimate the number of assignments/sales you expect to complete each week and multiply that number by 38. This will give you a total for your yearly assignments/sales. Finally, divide the total overhead expenses by the total number of assignments. This will give you an average price per assignment.

For example, let's say that your overhead expenses came to approximately $65,000 a year (this includes your $35,000 salary). If you completed two assignments each week for 38 weeks (76 assignments/year), your average price per assignment must equal approximately $855. This is what you should charge just to break even on each job.

Establishing Photo Usage

When pricing a photo or job, you must consider the usage: "What is going to be done with the photo?" Too often, photographers short-change themselves in negotiations because they do not understand how images will be used. Instead, they allow clients to set prices and prefer to accept lower fees rather than lose sales. Photographers argue they would rather make the sale than lose it because they refused to lower their price.

Unfortunately, those photographers who look at short-term profits are actually bringing down the entire industry. Clients realize, if they shop around, they can find photographers willing to shoot assignments or sell image rights at very low rates. Therefore, prices stay depressed because buyers, not photographers, are setting usage fees.

However, there are ways to combat low prices. First, educate yourself about a client's line of work. This type of professionalism helps during negotiations because it shows buyers you are serious about your work. The added knowledge also gives you an advantage when discussing fees because photographers are not expected to understand a client's profession.

For example, if most of your clients are in the advertising field, acquire advertising rate cards for magazines to learn what a client pays for ad space. You can find this information in most media kits. (See page 104 for a detailed discussion about media kit usage.) You

also can find ad rates in the SRDS directory, which can be found at your local library.

During negotiations it's good to know what clients pay for ads. Businesses routinely spend well over $100,000 on advertising space in national magazines. They establish budgets for such advertising campaigns, keeping the high ad rates in mind, but often restricting funds for photography. Ask yourself, "What's fair?" If the image is going to anchor a national advertisement and it conveys the perfect message for the client, don't settle for a low fee. Your image is the key to the campaign.

Some photographers, at least in the area of assignment work, operate on day rates or half-day rates. Editorial photographers will typically quote fees in the low hundreds, while advertising and corporate shooters may quote fees in the low thousands. However, photographers are finding that day rates by themselves are incomplete; they only account for time and don't substantiate numerous other pricing variables. In place of day rates, photographers are assessing "creative fees," which include overhead costs, profit and varying expenses, such as assignment time, experience and image value. They also bill clients for the number of finished pictures, rights purchased and additional expenses, like equipment rental and hiring assistants.

There are all sorts of ways to negotiate sales. Some clients, such as paper product companies, prefer to pay royalties on the number of times a product is sold. Special markets, like galleries and stock agencies, typically charge photographers a commission, from 20 to 50 percent, for displaying or representing their images. In these markets, payment on sales comes from the purchase of prints by gallery patrons or from commission on the rental of photos by clients of stock agencies. Pricing formulas should be developed depending on your costs and current price levels in those markets, as well as on the basis of submission fees, commissions and other administrative costs charged to you.

Bidding a Job

As you build your business, you will encounter another aspect of pricing and negotiating that can be very difficult. Like it or not, clients

often ask photographers to supply "bids" for jobs. In some cases, the bidding process is merely procedural, and the photographer who can best complete the job will receive the assignment. In other instances, the photographer who submits the lowest bid will earn the job. When contacted, it is imperative to find out which bidding process is being used. Putting together an accurate estimate takes time, and you do not want to waste a lot of effort if your bid is being sought merely to meet some quota.

However, correctly working through the steps is necessary if you want to succeed. You do not want to bid too much on a project and repeatedly get turned down, but you also don't want to bid too low and forfeit income. When a potential client calls to ask for a bid, there are several dos and don'ts to consider:

• Always keep a list of questions by the telephone to refer to when bids are requested. The questions should give you a solid understanding of the project and help you in reaching a price estimate.

• Never quote a price during the initial conversation, even if the caller pushes for a "ballpark figure." A spot estimate can only hurt you in the negotiating process.

• Immediately find out what the client intends to do with the photos, and ask who will own copyrights to the images after they are produced. It is important to note that many clients believe, if they hire you for a job, they own all rights to the images you create. If they want all rights, make sure the price they pay is worth it to you.

• If it is an annual project, ask who completed the job last time. Then contact that photographer to see what he charged.

• Ask who you are bidding against and contact those people to make sure you received the same information about the job. While agreeing to charge the same price is illegal, sharing information on prices is not.

• Talk to photographers not bidding on the project and ask them what they would charge.

• Finally, consider all aspects of the shoot, including preparation time, fees for assistants and stylists, rental equipment and other material costs. Don't leave anything out. (For an example of how to accurately estimate a project turn to page 23.)

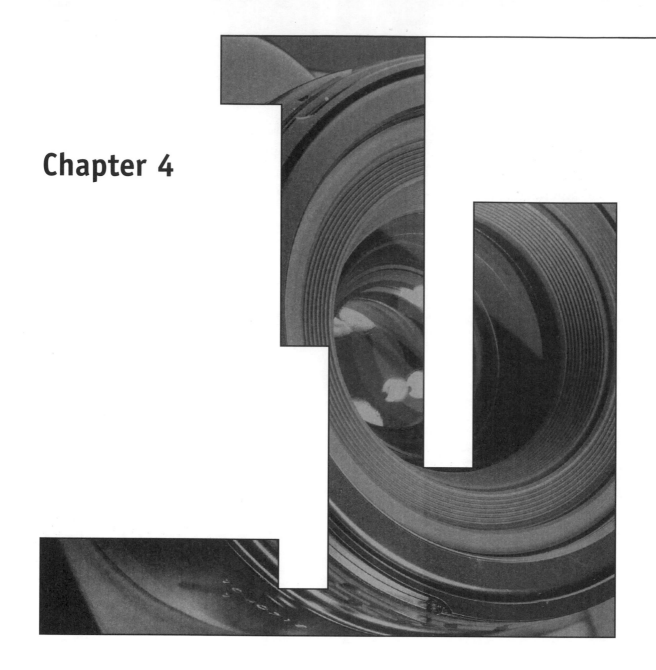

Chapter 4

Finding Representation

For many photographers, time spent in the office, on the phone cold calling or attending portfolio reviews is truly distasteful. They are turned off by the marketing process and would rather shoot photos than sell what they've created. If you fall into this category, there is an option worth considering: getting someone else to market your skills.

Joining a Stock Agency

If you are unfamiliar with how stock agencies work, the concept is easy to understand. Stock agencies house large files of images for contracted photographers and market the photos to potential buyers. In exchange for selling the images, agencies typically extract a 50 percent commission from each sale. The photographer receives the other 50 percent.

In the past fifteen to twenty years, the stock industry has witnessed enormous growth, with agencies popping up worldwide. However, as more and more agencies compete for sales, there has been a trend toward partnerships among some small to midsize agencies. In order to match the file content and financial strength of larger stock agencies, small agencies have begun to combine efforts when putting out catalogs and other promotional materials. In doing so, they've pooled their financial resources to produce top-notch catalogs, both print and CD-ROM.

Other agencies have been acquired by larger agencies and essentially turned into subsidiaries. Often these subsidiaries are strategically located to cover different portions of the world. Typically, smaller agencies are bought if they have images that fill a need for the parent company. For example, a small agency might specialize in animal photographs and be purchased by a larger agency that needs those images but doesn't want to search for individual wildlife photographers.

Seven Steps to Landing a Contract

So what does all of this mean to you? Well, the stock industry is extremely competitive, and if you intend to sell stock through an

agency, you must know how one works. What follows is a seven-step plan for landing a contract with an agency:

1. Build a solid base of quality images before contacting any agency. If you submit a package of fifty to one hundred images, an agency is going to want more if it's interested in your work. You want to have enough quality images in your files to withstand the initial review and get a contract.

2. Be prepared to supply new images on a regular basis. Most contracts stipulate that photographers must send additional submissions periodically—perhaps quarterly, monthly or annually. Unless you are committed to shooting regularly, or unless you have amassed a gigantic collection of images, don't pursue a stock agency.

3. Make sure all of your work is properly cataloged and identified with a file number. Start this process early so you're ready when agencies ask for this information. They'll need to know what is contained in each photograph so the images can be properly referenced in catalogs and on CD-ROMs.

4. Research those agencies that might be interested in your work. Often smaller agencies are more receptive to newcomers because they need to build their image files. When larger agencies seek new photographers, they usually want to see specific subjects on which photographers specialize. For detailed information about what types of subjects agencies need, check the latest *Photographer's Market* (Writer's Digest Books), available at bookstore and libraries. This annual directory lists over two hundred stock agencies worldwide that need new photographers.

5. Conduct reference checks on any agency you plan to approach to make sure it conducts business in a professional manner. Talk to current clients and other contracted photographers to see if they are happy with the agency. Remember you are interviewing the agency, too. If you are researching an American agency, see if the agency is a member of the Picture Agency Council of America,

(800) 457-7222. PACA members are required to practice certain standards of professionalism in order to maintain membership. A similar organization in the United Kingdom is the British Association of Picture Libraries and Agencies, (081) 883-2531. This is a quick way to examine the track record of most agencies.

Another item of note here: Some stock agencies are run by photographers who market their own work through their own agencies. If you are interested in working with such an agency, be certain your work will be given fair marketing treatment.

6. Once you've selected a stock agency, write a brief cover letter explaining that you are searching for an agency and that you would like to send some images for review. It's usually OK to include some samples (twenty to forty slides), but do not send originals. Only send duplicates for review so important work won't get lost or damaged. You also might be asked to submit a portfolio, so be prepared to do so. Always include an SASE (self-addressed, stamped envelope).

7. Finally, don't expect sales to roll in the minute a contract is signed. It usually takes a couple years before initial sales are made. Most agency sales come from catalogs, and often it takes a while for new images to get printed in a catalog.

Signing an Agreement

When reviewing stock agency contracts, there are a couple points to consider. First, it's common practice among many agencies to charge photographers fees, such as catalog insertion rates or image duping. Don't be alarmed and think the agency is trying to cheat you when you see these clauses. Besides, it might be possible to reduce or eliminate these fees through negotiation.

Another important item in most contracts deals with exclusive rights to market your images. Some agencies require exclusivity to sales of images they are marketing for you. In other words, you can't market the same images they have on file. This prevents photographers from undercutting agencies on sales. Such clauses are fair to

both sides as long as you can continue marketing images that are not in the agency's files.

An agency also may restrict your rights to sign with another stock house. Usually such clauses are merely designed to keep you from signing with a competitor. Be certain your contract allows you to work with other agencies. This may mean limiting the area of distribution for each agency. For example, one agency may get to sell your work in the United States while the other gets Europe. Or it could mean that one agency sells only to commercial clients, while the other handles editorial work.

Finally, be certain you understand the term limitations for your contract. Some agreements renew automatically with each submission of images. Others renew automatically after a period of time unless photographers terminate their contracts in writing. This might be a problem if you and your agency are at odds for any reason. So be certain you understand the contractual language before signing anything.

Finding a Photo Representative

If you have never dealt with photo representatives, you should know that they are nothing like traditional stock agencies. Photo reps are interested in marketing your talents rather than your images. Their main goal is to find assignment work for you with corporations, advertising firms or design studios. They will tote your portfolio around town to art directors, make cold calls in search of new clients and develop ways to promote your talents to the mass market.

Most reps handle such details for several photographers at one time, usually making certain that each shooter specializes in a different area. For example, a rep may have contracts to promote three different photographers, one who handles product shots, another who shoots interiors and a third who photographs food.

As you search for a representative, there are numerous points to consider. First, how established is the rep you plan to approach? Established reps have an edge over newcomers in that they know the territory. They've built up a batch of contacts in ad agencies, at

Sample Stock Agency Contract

FoodPix Content Partner Agreement

Agreement made as of the _____ day of _____ 19___, by and be-
tween _____ residing at _____,
_____ (hereinafter referred to as the "Artist") and Food-
Pix, a division of Burke/Triolo Productions with it's offices at 8755 Washington
Boulevard, Culver City, CA 90232 (hereinafter referred to as the "Agency" or
"FoodPix").

The Artist is engaged in the business of creating original images, or computer-
generated images in the form of color transparencies, or black-and-white negatives,
or digital files (hereinafter referred to as "Images"). FoodPix is in the business of
arranging for the license of Images to "Clients." The Artist and FoodPix have
determined that it is in their mutual interest to enter into this Agreement, whereby
FoodPix shall represent the Artist in attempting to license the Artist's Images to
Clients, upon such reasonable terms and conditions that FoodPix can arrange.

1. GRANT OF AUTHORITY:

(a) Appointment: The Artist hereby appoints FoodPix and FoodPix hereby accepts
such appointment, as the Artist's nonexclusive agent with respect to licensing the
Artist's Images.

(b) Ownership of Images: All images submitted to FoodPix pursuant to the terms
of this Agreement shall be, and remain, the Artist's exclusive property. FoodPix
will hold the Images as the Artist's Agent for the licensing purposes described
herein.

(c) Agency's Discretion as to Price: FoodPix shall have complete and sole discre-
tion regarding the terms, conditions and pricing of Images licensed to Clients.

(d) Discretion as to Lawsuits. FoodPix shall determine if, and when, any legal
action shall be pursued in regard to the Images, whether for copyright infringement,
loss, damage or any other reason, and shall have complete discretion regarding its
choice of attorney. Settlements shall not be subject to the Artist's prior approval.
FoodPix shall have no obligation to commence any legal action for any alleged
infringement, loss or damage of the images and the Artist agrees that FoodPix shall
have no liability for its failure to commence any action or proceeding.

(e) Use in Advertising: The Artist understands that FoodPix may use different
promotional methods to license the images, including but not limited to, using the
images in catalogs, online and in advertising. FoodPix may therefore use the images
in its own catalogs and advertising without any financial obligation to the Artist.

(f) No Use as Royalty Free: Artist warrants that any images submitted to FoodPix
have never been sold on a "Royalty Free" basis or as "Clip Art." Further, the
Artist agrees that none of their images accepted by FoodPix for the inclusion in
the FoodPix library may be sold by the Artist or any third party on a "Royalty
Free" basis or as "Clip Art" for as long as FoodPix acts as the stock agent for
that image.

Sample Stock Agency Contract continued through page 51.

2. TERM OF AGREEMENT: (a) Original and Renewal Term: This Agreement shall be for a period of three (3) years (the "Initial Period"). Either party shall have the right to terminate the Agreement during the last sixty (60) days prior to the expiration of the Initial Period, or any other Renewal Period, by notification to the other party, in writing. Due to the nature of the relationship between FoodPix and the Artist; FoodPix substantial investment in catalogs, publicity, editing of Images and other actions FoodPix will do on behalf of the Artist; and the fact that the Images will be distributed throughout the United States; this Agreement shall automatically renew itself for consecutive one (1) year periods (the "Renewal Period") unless the termination notice is timely received by the nonterminating party.

3. THE ARTIST'S OBLIGATIONS:

(a) Caption and Release Information: The Artist shall accurately caption all Images submitted to FoodPix and shall affix the proper copyright notice. The Artist shall also indicate whether there is a model or property release by writing "MR" on the Image's mount or on an accompanying transmittal sheet in the form requested by FoodPix. The Artist will attach a true copy of any and all model releases so indicated.

(b) Indemnification: The Artist agrees to indemnify FoodPix from any and all damages incurred by it, any of its Clients, or third parties in connection with the use of an improperly marked Image, or for any breach of any of the warranties in paragraph 4 of this agreement. The Artist further agrees to pay any defense costs incurred by FoodPix arising from an improperly marked Image or from a breach of any of the warranties of paragraph 4 of this agreement.

4. WARRANTIES OF THE ARTIST:

(a) That he/she is the sole and exclusive owner of, and has the sole and exclusive right to license, all Images he/she submits to FoodPix and has obtained all permissions necessary for FoodPix to lawfully license them.

(b) That no Image submitted infringes on any copyright or trademark law or any right of privacy or publicity, and does not knowingly defame any third party.

(c) That all color Images submitted to FoodPix are original transparencies or reproduction quality duplicates, or high quality digital files.

(d) That he/she has the right to enter into this Agreement and perform his/her obligations hereunder.

(e) That he/she will cooperate with FoodPix in all reasonable ways required, in order to further the purposes of this Agreement.

5. OBLIGATIONS OF AGENCY:

(a) FoodPix shall provide an appropriate environment for the storage, care and retrieval of the Artist's Images.

(b) FoodPix shall make efforts to license the Artist's Images and to receive reasonable fees for such licensing.

(c) FoodPix shall process all Images submitted by the Artist and will index, label and file all accepted Images.

(d) In agreements with Clients, FoodPix shall require that Images are protected by copyright in all uses, pursuant to the applicable law.

(e) FoodPix shall make efforts to protect and preserve the Images and will exercise reasonable care in the handling of the Images.

(f) FoodPix shall attempt to obtain image credit in the name of the Artist and FoodPix when and where applicable.

(g) FoodPix agrees not to sell any of the artist's images on a "Royalty Free" basis or as "Clip Art" without the express, prior, and written consent of the artist.

6. COMPENSATION:

(a) Percent of the Gross Billing: As consideration for FoodPix's services, FoodPix shall retain fifty percent (50%) of all gross billings in all licensing of Images.

(b) Gross Billings Defined: "Gross Billings" shall mean the revenue actually received by FoodPix for licensing the Artist's Images, but shall not include service or holding fees. Deductions from Gross Billings shall include, for example, bad debts and other uncollectable sums actually incurred.

(c) Statements: Each quarter FoodPix shall remit the Artist's share of funds received by Agency, along with a list of Images licensed.

(d) Deductions for Cancellation: In the event that FoodPix is required to refund any part of a payment received or accrued from a Client, FoodPix is specifically authorized to deduct this overpayment from any subsequent amount due the Artist.

(e) Compensation With Regard to Settlements and Lawsuits: All monies received as a result of a settlement or lawsuit in regard to lost or damaged Images, copyright infringement, or any other matter relating to the Images, shall be divided equally between the Artist and FoodPix, after payment of all costs including, but not limited to, attorneys' fees relating to such action.

(f) Compensation Subsequent to Termination: The Artist acknowledges that his Images will be out of FoodPix possession for some time subsequent to the termination of this Agreement. Moreover, it is possible that a Client will reuse, or be billed for a reuse of the Artist's Image subsequent to the termination of this Agreement. Accordingly, it is specifically agreed that FoodPix is authorized to collect and retain its normal commission for any sale, lease or re-lease or any right to an original or duplicate Image which may take place after this Agreement terminates for any reason.

(g) Right To Payment Upon Breach of Warranty: FoodPix shall have the right to use any percentage of the Artist's gross billing to defend or settle claims brought for any alleged violations of any of the warranties referenced in paragraphs 3 and 4 of this agreement

7. RETRIEVAL OF IMAGES:

(a) Allowable Time Period: Upon the termination of this Agreement, if the Artist requests FoodPix to do so in writing, FoodPix shall use all reasonable efforts to retrieve and turn over to the Artist all the Artist's Images in FoodPix's possession. The artist agrees that the retrieval of all transparencies may take as long as six (6) months, and FoodPix agrees to deliver small quantities of Images to the Artist as sufficient numbers are received by it. Retrieval and delivery to the Artist shall not

require more than nine (9) months after termination with respect to the Artist's Images located in FoodPix's files.

(b) Liability for Non-Return: The Artist acknowledges that FoodPix cannot maintain insurance on its Image Library for any commercially reasonable cost. Accordingly, the Artist SPECIFICALLY AGREES that he will not seek to hold FoodPix financially responsible for any Images that it cannot retrieve, for any reason, at the termination of this Agreement. The Artist's representation that FoodPix will not be sued, nor will any damages be sought from it in the event FoodPix loses or cannot retrieve any Image, IS A MATERIAL INDUCEMENT FOR FOODPIX TO ENTER INTO THIS AGREEMENT. The Artist is advised to insure any Images he submits to FoodPix.

8. DEATH OR DISABILITY OF THE ARTIST: In the event the Artist dies, becomes disabled or incompetent during the term of this Agreement, FoodPix will send payments due to the Artist to his personal representative upon legal notification of such appointment.

9. INABILITY TO LOCATE ARTIST:

(a) Alternate Notice: FoodPix shall use reasonable efforts to locate the Artist in the event statements are returned unclaimed. To assist FoodPix in this endeavor, the Artist shall provide FoodPix with an alternate address on the signature page of this agreement. The Artist shall also be obligated to provide FoodPix with information regarding any change in his address.

(b) Retention of Billings: In the event that, notwithstanding FoodPix reasonable efforts, the Artist cannot be located for three (3) years, FoodPix shall have the right to retain any unclaimed payments.

10. INDEPENDENT CONTRACTOR: The parties hereto acknowledge that this Agreement is one of Agency only. This does not constitute an employment agreement and FoodPix is acting in the capacity of an independently retained agent on the Artist's behalf. FoodPix will not bind the Artist contrary to the terms hereof.

11. MISCELLANEOUS PROVISIONS:

(a) Limitations on Assignment: FoodPix may not assign this Agreement without the prior written consent of the Artist but the Agreement may be assumed by any corporation which succeeds FoodPix due to a merger or reorganization.

(b) Binding Nature: Except as may otherwise be provided herein, this Agreement shall be binding upon and shall inure to the benefit of the respective heirs, executors, administrators, successors and assigns of the parties hereto.

(c) Entire Agreement: This Agreement incorporates the entire understanding of the parties concerning the subject matter contained herein and all prior understanding, representations, discussions, or customs, whether written or oral, are specifically merged herein. This Agreement may not be modified, amended, or otherwise changed in any respect except by a separate writing signed by both parties.

(d) Governing Law: This Agreement, and all matters collateral thereto, shall be construed according to the laws of the State of California, County of Los Angeles, and any controversy arising hereunder shall be litigated solely in a court of competent jurisdiction of such state and county.

12. GOOD FAITH: Both parties are entering into this Agreement in good faith and will continue to work in union to further the best interests of the other party and promote the intent of this Agreement.

IN WITNESS WHEREOF, The parties have executed this Agreement on the day and the date first set forth above.

For FoodPix

By: _____

 Jeffrey T. Burke
 Sole Owner of FoodPix

For the Artist

Signature

Alternate (If Different from Page 1)

Business Telephone

magazines and elsewhere. This is essential since most art directors and picture editors do not stay in their positions for long periods of time. Therefore, established reps will have an easier time helping you penetrate new markets.

If you decide to go with a new rep, consider paying an advance against commission in order to help the rep financially during an equitable trial period. Usually it takes a year to see returns on portfolio reviews and other marketing efforts, and a representative who is relying on income from sales might go hungry if she doesn't have a base income from which to live. Reps usually receive 25 to 30 percent commissions on sales.

And whatever you agree upon, always have a written agreement. Handshake deals won't cut it. You must know the tasks each of you are required to complete, and having your roles discussed in a contract will reduce the likelihood of any misunderstandings. For example,

spell out in your contract what happens with clients you had before hiring the rep. Most photographers refuse to pay commissions for these "house" accounts unless the rep handles them completely and continues to bring in new clients.

It's also important to establish the billing procedures. Who is in charge of collecting money and paying the other half the appropriate share? Normally this task is left up to the photographer, but the rep could handle this task, too. Also, it's likely that some costs, such as promotional fees, will be shared. The rates should be spelled out in the contract.

If you want to know more about specific photo representatives or how reps operate, contact the Society of Photographer and Artist Representatives, 60 E. Forty-second St., Suite 1166, New York, NY 10165, (212) 779-7464. SPAR sponsors educational programs and maintains a code of ethics to which all members must adhere.

Working With Galleries

Fine art photographers will discover that marketing their images through a stock house is not practical. Usually such artists explore themes and subjects that require numerous photos. Often the concepts do not lend themselves to stock or the mass market. And photo reps generally do not look to sign fine artists because in most cases their work does not appeal to commercial clients. Enter galleries.

In exchange for brokering images, galleries often receive a commission of 40 to 50 percent. They usually exhibit work for a month, sometimes longer, and hold openings to kick off new shows. And they frequently provide pre-exhibition publicity. Something to be aware of is that some smaller galleries require exhibiting photographers to help with opening night reception expenses. Galleries may require photographers to appear during the show or opening. Be certain such policies are put in writing before you allow a gallery to show your work.

Gallery directors who foresee a bright future for you might want exclusive rights to represent you. This type of representation forces buyers to get your images directly from the gallery that represents

you. Such contracts are quite common, usually limiting the exclusive rights to specified distances. For example, a gallery in Tulsa may have exclusive rights to distribute your work within a 200-mile radius of the gallery. This would allow you to sign similar contracts with galleries outside the 200-mile range.

Some arrangements require photographers to pay commissions even if they make the sales themselves without the help of the gallery. The reason for this is to prevent photographers from undercutting the prices inside the gallery. You may consider such contractual arrangements to be too limiting, but remember that galleries have overhead expenses you as an artist don't have; they must pay for available space, promotional materials and other operational expenses.

Along with commercial galleries, there are two other types of galleries you may encounter: co-ops and nonprofits. A co-op is run by a group of artists who rent or own the gallery space in order to display and sell their own work. Some co-ops are interested in taking on new members, or possibly adding other photographers to specific shows. If you get involved with a co-op, understand that you will be required to help with various aspects of maintaining the operation. Some financial support may be required, too.

Unlike commercial galleries, nonprofits are not run as a business. They are more interested in giving artists a place to show their work. Frequently, universities and businesses support galleries that have nonprofit status. If you show work in a nonprofit space, you may be asked to pay a fee or small percentage of your sales in order to cover the cost of operating the gallery.

For more on working with galleries, turn to chapter twelve.

Chapter 5

Copyright

This chapter discusses one of the most important aspects of professional photography—the issue of copyright. It's easy to ignore copyright registration of your images, and it's easy to lose control of your image rights if you aren't paying attention to the contracts you sign. This chapter explains the copyright laws, shows you how simple it is to register your work and gives you some common language in contracts that are designed to give buyers your image rights.

First, there is a major issue to address up front: Once you create a photo, it becomes yours. You own the copyright, regardless of whether you register it with the Copyright Office in Washington, DC. But you cannot copyright an idea. Just thinking about something that would make a great photograph does not make that scene yours. You actually must have something documented on film.

The fact that an image is automatically copyrighted does not mean it shouldn't be registered. Quite the contrary. You cannot even file a copyright infringement suit until you've registered your work. Without timely registration of your images, you can only recover actual damages—money lost as a result of sales by the infringer plus any profits the infringer earned. Recovering $2,000, for example, for an ad sale can be minimal when weighed against the expense of hiring a copyright attorney. Often this deters photographers from filing lawsuits if they haven't registered their work. They know the attorney's fees will be more than the actual damages recovered, and, therefore, infringers go unpunished.

If you really want to grasp the copyright issue, consider this: *Theft of your images creates a loss of your income.* After all, a person who steals one of your photos uses it for a project, his project or someone else's. That's a lost sale for which you will never be paid, especially if you never find out the image was stolen.

Why Should You Register?

So what makes copyright so important to a photographer? First of all, there's the moral issue. Simply put, stealing someone's work is wrong, and it's a joyous occasion when an infringer is caught and punished. By registering your photos, you are safeguarding against

theft. You're making sure that if someone illegally procures one of your images, she can be held accountable. Actually, infringers count on the fact that most photographers won't register their images. They assume (1) the photographer will never find out and (2) if they are caught, they can always settle out of court. Infringers assume the settlement will only be for a few thousand dollars. Therefore, it's worth the risk to steal images.

Registration allows you to recover certain damages to which you otherwise would not be legally entitled. Attorney fees and court costs, for instance, can be recovered. So, too, can statutory damages—awards based on how deliberate and harmful the infringement. Statutory damages can run as high as $100,000. These are the fees that make registration so important.

In order to recover these fees, there are certain rules regarding registration that you must follow. The rules have to do with the timeliness of your registration in relation to the infringement:

- Unpublished images must be registered before the infringement takes place.

- Published images must be registered within three months of the first date of publication or before the infringement began.

How to Register

The process of registering your work is simple. Contact the Register of Copyrights, Library of Congress, Washington, DC 20559, (202) 707-9100, and ask for Form VA (works of the visual arts). Registration costs twenty dollars, but you can register photographs in large quantities for that fee. One requirement of which you should be aware is that whatever you send to the Copyright Office is kept there. Your images will not be returned, so don't send originals. Some photographers actually gang register their work by videotaping hundreds of slides onto one standard VHS tape and sending it to the Copyright Office with their twenty-dollar fee. If you have any questions about what's acceptable for gang registration, contact the Copyright Office.

Filling Out Application Form VA

Detach and read these instructions before completing this form.
Make sure all applicable spaces have been filled in before you return this form.

BASIC INFORMATION

When to Use This Form: Use Form VA for copyright registration of published or unpublished works of the visual arts. This category consists of "pictorial, graphic, or sculptural works," including two-dimensional and three-dimensional works of fine, graphic, and applied art, photographs, prints and art reproductions, maps, globes, charts, technical drawings, diagrams, and models.

What Does Copyright Protect? Copyright in a work of the visual arts protects those pictorial, graphic, or sculptural elements that, either alone or in combination, represent an "original work of authorship." The statute declares: "In no case does copyright protection for an original work of authorship extend to any idea, procedure, process, system, method of operation, concept, principle, or discovery, regardless of the form in which it is described, explained, illustrated, or embodied in such work."

Works of Artistic Craftsmanship and Designs: "Works of artistic craftsmanship" are registrable on Form VA, but the statute makes clear that protection extends to "their form" and not to "their mechanical or utilitarian aspects." The "design of a useful article" is considered copyrightable "only if, and only to the extent that, such design incorporates pictorial, graphic, or sculptural features that can be identified separately from, and are capable of existing independently of, the utilitarian aspects of the article."

Labels and Advertisements: Works prepared for use in connection with the sale or advertisement of goods and services are registrable if they contain "original work of authorship." Use Form VA if the copyrightable material in the work you are registering is mainly pictorial or graphic; use Form TX if it consists mainly of text. NOTE: Words and short phrases such as names, titles, and slogans cannot be protected by copyright, and the same is true of standard symbols, emblems, and other commonly used graphic designs that are in the public domain. When used commercially, material of that sort can sometimes be protected under state laws of unfair competition or under the Federal trademark laws. For information about trademark registration, write to the Commissioner of Patents and Trademarks, Washington, D.C. 20231.

Architectural Works: Copyright protection extends to the design of buildings created for the use of human beings. Architectural works created on or after December 1, 1990, or that on December 1, 1990, were unconstructed and embodied only in unpublished plans or drawings are eligible. Request Circular 41 for more information.

Deposit to Accompany Application: An application for copyright registration must be accompanied by a deposit consisting of copies representing the entire work for which registration is to be made.

Unpublished Work: Deposit one complete copy.

Published Work: Deposit two complete copies of the best edition.

Work First Published Outside the United States: Deposit one complete copy of the first foreign edition.

Contribution to a Collective Work: Deposit one complete copy of the best edition of the collective work.

The Copyright Notice: For works first published on or after March 1, 1989, the law provides that a copyright notice in a specified form "may be placed on all publicly distributed copies from which the work can be visually perceived." Use of the copyright notice is the responsibility of the copyright owner and does not require advance permission from the Copyright Office. The required form of the notice for copies generally consists of three elements: (1) the symbol "©", or the word "Copyright," or the abbreviation "Copr."; (2) the year of first publication; and (3) the name of the owner of copyright. For example: "© 1995 Jane Cole." The notice is to be affixed to the copies "in such manner and location as to give reasonable notice of the claim of copyright." Works first published prior to March 1, 1989 , must carry the notice or risk loss of copyright protection.

For information about notice requirements for works published before March 1, 1989, or other copyright information, write: Information Section, LM-401, Copyright Office, Library of Congress, Washington, D.C. 20559-6000.

LINE-BY-LINE INSTRUCTIONS

Please type or print using black ink.

1 SPACE 1: Title

Title of This Work: Every work submitted for copyright registration must be given a title to identify that particular work. If the copies of the work bear a title (or an identifying phrase that could serve as a title), transcribe that wording completely and exactly on the application. Indexing of the registration and future identification of the work will depend on the information you give here. For an architectural work that has been constructed, add the date of construction after the title; if unconstructed at this time, add "not yet constructed."

Previous or Alternative Titles: Complete this space if there are any additional titles for the work under which someone searching for the registration might be likely to look, or under which a document pertaining to the work might be recorded.

Publication as a Contribution: If the work being registered is a contribution to a periodical, serial, or collection, give the title of the contribution in the "Title of This Work" space. Then, in the line headed "Publication as a Contribution," give information about the collective work in which the contribution appeared.

Nature of This Work: Briefly describe the general nature or character of the pictorial, graphic, or sculptural work being registered for copyright. Examples: "Oil Painting"; "Charcoal Drawing"; "Etching"; "Sculpture"; "Map"; "Photograph"; "Scale Model"; "Lithographic Print"; "Jewelry Design"; "Fabric Design."

2 SPACE 2: Author(s)

General Instruction: After reading these instructions, decide who are the "authors" of this work for copyright purposes. Then, unless the work is a "collective work," give the requested information about every "author" who contributed any appreciable amount of copyrightable matter to this version of the work. If you need further space, request Continuation Sheets. In the case of a collective work, such as a catalog of paintings or collection of cartoons by various authors, give information about the author of the collective work as a whole.

Name of Author: The fullest form of the author's name should be given. Unless the work was "made for hire," the individual who actually created the work is its "author." In the case of a work made for hire, the statute provides that "the employer or other person for whom the work was prepared is considered the author."

What is a "Work Made for Hire"? A "work made for hire" is defined as: (1) "a work prepared by an employee within the scope of his or her employment"; or (2) " a work specially ordered or commissioned for use as a contribution to a collective work, as a part of a motion picture or other audiovisual work, as a translation, as a supplementary work, as a compilation, as an instructional text, as a test, as answer material for a test, or as an atlas, if the parties expressly agree in a written instrument signed by them that the work shall be considered a work made for hire." If you have checked "Yes" to indicate that the work was "made for hire," you must give the full legal name of the employer (or other person for whom the work was prepared). You may also include the name of the employee along with the name of the employer (for example: "Elster Publishing Co., employer for hire of John Ferguson").

"Anonymous" or "Pseudonymous" Work: An author's contribution to a work is "anonymous" if that author is not identified on the copies or phonorecords of the work. An author's contribution to a work is "pseudonymous" if that author is identified on the copies or phonorecords under a fictitious name. If the work is "anonymous" you may: (1) leave the line blank; or (2) state "anonymous" on the line; or (3) reveal the author's identity. If the work is "pseudonymous" you may: (1) leave the line blank; or (2) give the pseudonym and identify it as such (for example: "Huntley Haverstock, pseudonym"); or (3) reveal the author's name, making clear which is the real name and which is the pseudonym (for example: "Henry Leek, whose pseudonym is Priam Farrel"). However, the citizenship or domicile of the author must be given in all cases.

Dates of Birth and Death: If the author is dead, the statute requires that the year of death be included in the application unless the work is anonymous or pseudonymous. The author's birth date is optional but is useful as a form of identification. Leave this space blank if the author's contribution was a "work made for hire."

Author's Nationality or Domicile: Give the country of which the author is a citizen or the country in which the author is domiciled. Nationality or domicile must be given in all cases.

Copyright Registration Form VA (pages 57-60)

Nature of Authorship: Catagories of pictorial, graphic, and sculptural authorship are listed below. Check the box(es) that best describe(s) each author's contribution to the work.

3-Dimensional sculptures: fine art sculptures, toys, dolls, scale models, and sculptural designs applied to useful articles.

2-Dimensional artwork: watercolor and oil paintings; pen and ink drawings; logo illustrations; greeting cards; collages; stencils; patterns; computer graphics; graphics appearing in screen displays; artwork appearing on posters, calendars, games, commercial prints and labels, and packaging, as well as 2-dimensional artwork applied to useful articles.

Reproductions of works of art: reproductions of preexisting artwork made by, for example, lithography, photoengraving, or etching.

Maps: cartographic representations of an area such as state and county maps, atlases, marine charts, relief maps, and globes.

Photographs: pictorial photographic prints and slides and holograms.

Jewelry designs: 3-dimensional designs applied to rings, pendants, earrings, necklaces, and the like.

Designs on sheetlike materials: designs reproduced on textiles, lace, and other fabrics; wallpaper; carpeting; floor tile; wrapping paper; and clothing.

Technical drawings: diagrams illustrating scientific or technical information in linear form such as architectural blueprints or mechanical drawings.

Text: textual material that accompanies pictorial, graphic, or sculptural works such as comic strips, greeting cards, games rules, commercial prints or labels, and maps.

Architectural works: designs of buildings, including the overall form as well as the arrangement and composition of spaces and elements of the design. NOTE: Any registration for the underlying architectural plans must be applied for on a separate Form VA, checking the box "Technical drawing."

3 SPACE 3: Creation and Publication

General Instructions: Do not confuse "creation" with "publication." Every application for copyright registration must state "the year in which creation of the work was completed." Give the date and nation of first publication only if the work has been published.

Creation: Under the statute, a work is "created" when it is fixed in a copy or phonorecord for the first time. Where a work has been prepared over a period of time, the part of the work existing in fixed form on a particular date constitutes the created work on that date. The date you give here should be the year in which the author completed the particular version for which registration is now being sought, even if other versions exist or if further changes or additions are planned.

Publication: The statute defines "publication" as "the distribution of copies or phonorecords of a work to the public by sale or other transfer of ownership, or by rental, lease, or lending"; a work is also "published" if there has been an "offering to distribute copies or phonorecords to a group of persons for purposes of further distribution, public performance, or public display." Give the full date (month, day, year) when, and the country where, publication first occurred. If first publication took place simultaneously in the United States and other countries, it is sufficient to state "U.S.A."

4 SPACE 4: Claimant(s)

Name(s) and Address(es) of Copyright Claimant(s): Give the name(s) and address(es) of the copyright claimant(s) in this work even if the claimant is the same as the author. Copyright in a work belongs initially to the author of the work (including, in the case of a work made for hire, the employer or other person for whom the work was prepared). The copyright claimant is either the author of the work or a person or organization to whom the copyright initially belonging to the author has been transferred.

Transfer: The statute provides that, if the copyright claimant is not the author, the application for registration must contain "a brief statement of how the claimant obtained ownership of the copyright." If any copyright claimant named in space 4 is not an author named in space 2, give a brief statement explaining how the claimant(s) obtained ownership of the copyright. Examples: "By written contract"; "Transfer of all rights by author"; "Assignment"; "By will." Do not attach transfer documents or other attachments or riders.

5 SPACE 5: Previous Registration

General Instructions: The questions in space 5 are intended to find out whether an earlier registration has been made for this work and, if so, whether

there is any basis for a new registration. As a rule, only one basic copyright registration can be made for the same version of a particular work.

Same Version: If this version is substantially the same as the work covered by a previous registration, a second registration is not generally possible unless: (1) the work has been registered in unpublished form and a second registration is now being sought to cover this first published edition; or (2) someone other than the author is identified as a copyright claimant in the earlier registration, and the author is now seeking registration in his or her own name. If either of these two exceptions apply, check the appropriate box and give the earlier registration number and date. Otherwise, do not submit Form VA; instead, write the Copyright Office for information about supplementary registration or recordation of transfers of copyright ownership.

Changed Version: If the work has been changed and you are now seeking registration to cover the additions or revisions, check the last box in space 5, give the earlier registration number and date, and complete both parts of space 6 in accordance with the instruction below.

Previous Registration Number and Date: If more than one previous registration has been made for the work, give the number and date of the latest registration.

6 SPACE 6: Derivative Work or Compilation

General Instructions: Complete space 6 if this work is a "changed version," "compilation," or "derivative work," and if it incorporates one or more earlier works that have already been published or registered for copyright, or that have fallen into the public domain. A "compilation" is defined as "a work formed by the collection and assembling of preexisting materials or of data that are selected, coordinated, or arranged in such a way that the resulting work as a whole constitutes an original work of authorship." A "derivative work" is "a work based on one or more preexisting works." Examples of derivative works include reproductions of works of art, sculptures based on drawings, lithographs based on paintings, maps based on previously published sources, or "any other form in which a work may be recast, transformed, or adapted." Derivative works also include works "consisting of editorial revisions, annotations, or other modifications" if these changes, as a whole, represent an original work of authorship.

Preexisting Material (space 6a): Complete this space and space 6b for derivative works. In this space identify the preexisting work that has been recast, transformed, or adapted. Examples of preexisting material might be "Grunewald Altarpiece" or "19th century quilt design." Do not complete this space for compilations.

Material Added to This Work (space 6b): Give a brief, general statement of the additional new material covered by the copyright claim for which registration is sought. In the case of a derivative work, identify this new material. Examples: "Adaptation of design and additional artistic work"; "Reproduction of painting by photolithography"; "Additional cartographic material"; "Compilation of photographs." If the work is a compilation, give a brief, general statement describing both the material that has been compiled and the compilation itself. Example: "Compilation of 19th century political cartoons."

7,8,9 SPACE 7,8,9: Fee, Correspondence, Certification, Return Address

Deposit Account: If you maintain a Deposit Account in the Copyright Office, identify it in space 7. Otherwise leave the space blank and send the fee of $20 with your application and deposit.

Correspondence (space 7): This space should contain the name, address, area code, and telephone number of the person to be consulted if correspondence about this application becomes necessary.

Certification (space 8): The application cannot be accepted unless it bears the date and the handwritten signature of the author or other copyright claimant, or of the owner of exclusive right(s), or of the duly authorized agent of the author, claimant, or owner of exclusive right(s).

Address for Return of Certificate (space 9): The address box must be completed legibly since the certificate will be returned in a window envelope.

FORM VA
For a Work of the Visual Arts
UNITED STATES COPYRIGHT OFFICE

REGISTRATION NUMBER

VA VAU

EFFECTIVE DATE OF REGISTRATION

Month Day Year

DO NOT WRITE ABOVE THIS LINE. IF YOU NEED MORE SPACE, USE A SEPARATE CONTINUATION SHEET.

1

TITLE OF THIS WORK ▼

NATURE OF THIS WORK ▼ See instructions

PREVIOUS OR ALTERNATIVE TITLES ▼

PUBLICATION AS A CONTRIBUTION If this work was published as a contribution to a periodical, serial, or collection, give information about the collective work in which the contribution appeared. **Title of Collective Work ▼**

If published in a periodical or serial give: Volume ▼ Number ▼ Issue Date ▼ On Pages ▼

2

a

NAME OF AUTHOR ▼

DATES OF BIRTH AND DEATH
Year Born ▼ Year Died ▼

Was this contribution to the work a "work made for hire"?
☐ Yes
☐ No

AUTHOR'S NATIONALITY OR DOMICILE
Name of Country
OR { Citizen of ▶ _____
Domiciled in▶ _____

WAS THIS AUTHOR'S CONTRIBUTION TO THE WORK
Anonymous? ☐ Yes ☐ No
Pseudonymous? ☐ Yes ☐ No
If the answer to either of these questions is "Yes," see detailed instructions.

NATURE OF AUTHORSHIP Check appropriate box(es). **See instructions**
☐ 3-Dimensional sculpture ☐ Map ☐ Technical drawing
☐ 2-Dimensional artwork ☐ Photograph ☐ Text
☐ Reproduction of work of art ☐ Jewelry design ☐ Architectural work
☐ Design on sheetlike material

NOTE
Under the law, the "author" of a "work made for hire" is generally the employer, not the employee (see instructions). For any part of this work that was "made for hire" check "Yes" in the space provided, give the employer (or other person for whom the work was prepared) as "Author" of that part, and leave the space for dates of birth and death blank.

b

NAME OF AUTHOR ▼

DATES OF BIRTH AND DEATH
Year Born ▼ Year Died ▼

Was this contribution to the work a "work made for hire"?
☐ Yes
☐ No

AUTHOR'S NATIONALITY OR DOMICILE
Name of Country
OR { Citizen of ▶ _____
Domiciled in▶ _____

WAS THIS AUTHOR'S CONTRIBUTION TO THE WORK
Anonymous? ☐ Yes ☐ No
Pseudonymous? ☐ Yes ☐ No
If the answer to either of these questions is "Yes," see detailed instructions.

NATURE OF AUTHORSHIP Check appropriate box(es). **See instructions**
☐ 3-Dimensional sculpture ☐ Map ☐ Technical drawing
☐ 2-Dimensional artwork ☐ Photograph ☐ Text
☐ Reproduction of work of art ☐ Jewelry design ☐ Architectural work
☐ Design on sheetlike material

3

a **YEAR IN WHICH CREATION OF THIS WORK WAS COMPLETED** This information must be given ◀Year in all cases.

b **DATE AND NATION OF FIRST PUBLICATION OF THIS PARTICULAR WORK** Complete this information ONLY if this work has been published. Month▶ _____ Day▶ _____ Year▶ _____ ◀ Nation

4

See instructions before completing this space.

COPYRIGHT CLAIMANT(S) Name and address must be given even if the claimant is the same as the author given in space 2. ▼

TRANSFER If the claimant(s) named here in space 4 is (are) different from the author(s) named in space 2, give a brief statement of how the claimant(s) obtained ownership of the copyright. ▼

DO NOT WRITE HERE
OFFICE USE ONLY

APPLICATION RECEIVED

ONE DEPOSIT RECEIVED

TWO DEPOSITS RECEIVED

FUNDS RECEIVED

MORE ON BACK ▶ • Complete all applicable spaces (numbers 5-9) on the reverse side of this page.
• See detailed instructions. • Sign the form at line 8.

DO NOT WRITE HERE
Page 1 of _____ pages

EXAMINED BY	FORM VA
CHECKED BY	
☐ CORRESPONDENCE Yes	FOR COPYRIGHT OFFICE USE ONLY

DO NOT WRITE ABOVE THIS LINE. IF YOU NEED MORE SPACE, USE A SEPARATE CONTINUATION SHEET.

PREVIOUS REGISTRATION Has registration for this work, or for an earlier version of this work, already been made in the Copyright Office?

☐ Yes ☐ No If your answer is "Yes," why is another registration being sought? (Check appropriate box) ▼

a. ☐ This is the first published edition of a work previously registered in unpublished form.

b. ☐ This is the first application submitted by this author as copyright claimant.

c. ☐ This is a changed version of the work, as shown by space 6 on this application.

If your answer is "Yes," give: **Previous Registration Number** ▼ **Year of Registration** ▼

5

DERIVATIVE WORK OR COMPILATION Complete both space 6a and 6b for a derivative work; complete only 6b for a compilation.

a. Preexisting Material Identify any preexisting work or works that this work is based on or incorporates. ▼

b. Material Added to This Work Give a brief, general statement of the material that has been added to this work and in which copyright is claimed. ▼

6

See instructions before completing this space.

DEPOSIT ACCOUNT If the registration fee is to be charged to a Deposit Account established in the Copyright Office, give name and number of Account.

Name ▼ **Account Number** ▼

7

CORRESPONDENCE Give name and address to which correspondence about this application should be sent. Name/Address/Apt/City/State/ZIP ▼

Area Code and Telephone Number ▶

Be sure to give your daytime phone number

CERTIFICATION* I, the undersigned, hereby certify that I am the

check only one ▼

☐ author

☐ other copyright claimant

☐ owner of exclusive right(s)

☐ authorized agent of _____

Name of author or other copyright claimant, or owner of exclusive right(s) ▲

of the work identified in this application and that the statements made by me in this application are correct to the best of my knowledge.

Typed or printed **name and date** ▼ If this application gives a date of publication in space 3, do not sign and submit it before that date.

Date ▶ _____

☞ Handwritten signature (X) ▼

8

Mail certificate to:

Certificate will be mailed in window envelope

Name ▼
Number/Street/Apt ▼
City/State/ZIP ▼

YOU MUST
• Complete all necessary spaces
• Sign your application in space 8

SEND ALL 3 ELEMENTS IN THE SAME PACKAGE
1. Application form
2. Nonrefundable $20 filing fee in check or money order payable to *Register of Copyrights*
3. Deposit material

MAIL TO
Register of Copyrights
Library of Congress
Washington, D.C. 20559-6000

9

*17 U.S.C. § 506(e): Any person who knowingly makes a false representation of a material fact in the application for copyright registration provided for by section 409, or in any written statement filed in connection with the application, shall be fined not more than $2,500.

March 1995—300,000 ♻ PRINTED ON RECYCLED PAPER ☆U.S. GOVERNMENT PRINTING OFFICE: 1995-387-237/41

The Copyright Notice

Another way to protect your work is to mark each image with a copyright notice. This informs everyone reviewing your work that you own the copyright. It may seem basic, but in court this can be very important. In a lawsuit, one avenue of defense for an infringer is "innocent infringement"—basically the "I-didn't-know" argument. By placing your copyright notice on your images, you negate this defense for an infringer.

The copyright notice basically consists of three elements: the symbol, the year of first publication and the copyright holder's name. Here's an example of a copyright notice for an image published in 1997: 1997 Michael S. Willins. Instead of the symbol ©, you can use the word *Copyright* or simply *Copr.* However, most foreign countries prefer © as a common designation. Also consider adding *All rights reserved* after your copyright notice. This phrase is not necessary in the United States since all rights are automatically reserved; however, it is recommended in other parts of the world.

One final note here: When you submit photos to clients, especially those with whom you have never worked, it's a good idea to mention that your images have been registered with the Copyright Office. Don't use this fact as a scare tactic with clients, but it might help prevent infringement if buyers know they could face serious repercussions if they steal your photos.

Know Your Rights

The digital era is making copyright protection difficult. Often, images are manipulated so it's nearly impossible to recognize original versions of photos. As technology improves, more clients will want digital versions of your photos. Don't be alarmed; just be careful. Not all clients want to steal your work. They often need digital versions to conduct color separations or place artwork for printers.

When you negotiate the usage of your work, add a phrase to your contract that limits the rights of buyers who want digital versions of your photos. The following phrase, for example, could be placed in your terms and conditions to restrict image alterations:

Client will not make or permit any alterations, additions or subtractions to the photographs, including without limitation any digitization of the photographs, alone or with any other material, by use of computer or other electronic means or any other method or means now or hereafter known.

In addition, you should require the removal of images from computer files once they are used. The important thing is to discuss what the client intends to do with the image and spell it out in writing.

It is understandable for a client not to want a photo she used to appear in a competitor's ad. Skillful negotiation usually can result in an agreement that says the image will not be sold to a competitor, but could be sold to other industries, possibly offering regional exclusivity for a stated time period.

Even a knowledgeable photographer will find himself at risk when dealing with a misinformed or intentionally deceptive client. So it's essential not only to know your rights under the Copyright Law, but also to make sure every photo buyer you deal with understands them. The following list of typical image rights should help you deal with clients:

One-time rights. These photos are "leased" on a one-time basis; one fee is paid for one use.

First rights. This is generally the same as purchase of one-time rights, though the photo buyer is paying a bit more for the privilege of being the first to use the image. She may use it only once unless other rights are negotiated.

Serial rights. The photographer has sold the right to use the photo in a periodical. It shouldn't be confused with using the photo in "installments." Most magazines will want to be sure the photo won't be running in a competing publication.

Exclusive rights. Exclusive rights guarantee the buyer's exclusive right to use the photo in his particular market or for a particular product. A greeting card company, for example, may purchase these

rights to an image with the stipulation that it not be sold to a competing company for a certain time period. The photographer, however, may retain rights to sell the image to other markets. Conditions should always be in writing to avoid any misunderstandings.

Electronic rights. These rights allow buyers to place your work on electronic media, such as CD-ROMs or online services. Often these rights are requested with print rights. Since more and more consumers are accessing information via the Internet, buyers are often willing to pay extra for electronic rights.

Promotion rights. Such rights allow a publisher to use the photographer's photo for promotion of a publication in which the photo appears. The photographer should be paid for promotional use in addition to the rights first sold to reproduce the image. Another form of this—agency promotion rights—is common among stock photo agencies. Likewise, the terms of this need to be negotiated separately.

Work for hire. Under the Copyright Act of 1976, these rights are defined as "a work prepared by an employee within the scope of his or her employment." If a written agreement is reached between the photographer and buyer, then the following also apply as work for hire: commissioned works completed as part of collective projects, work for motion picture or audiovisual projects, and supplementary work.

All rights. This involves selling or assigning all rights to a photo for a specified period of time. This differs from work for hire, in which the photographer permanently surrenders all rights to a photo and any claims to royalties or other future compensation. Terms for all rights—including time period of usage and compensation—should be negotiated and confirmed in a written agreement with the client.

Chapter 6

The Portfolio

Your success or failure as a professional photographer hinges on your ability to sell your talents. You must present yourself to potential clients in the best possible manner and convince them you can handle assignments and solve their problems 100 percent of the time. They must have confidence in your skills, otherwise you won't see repeat sales or assignments.

When it comes to building a client's confidence in you, the key is to have a professional, clever portfolio. Art buyers hate sloppy portfolios (also known as "books"). They assume that if you aren't willing to put some effort into the presentation of your work, then you won't provide the needed effort on assignments.

There are several variables to consider when producing your portfolio:

- **The size and format of your work.** Are you presenting 20×24 prints or 35mm slides? If you work exclusively with transparencies, how are you going to show them off? Perhaps you have images stored digitally and, therefore, want to inform buyers you can supply images online or on disk. What's the best way to accomplish this task?

- **What the buyers prefer.** Do they have CD-ROM drives or Internet access to review electronic portfolios? Are they willing to review a slide tray filled with forty to fifty images?

- **Your proximity to the markets.** Do you have to mail the portfolio? Is the buyer nearby and willing to schedule portfolio reviews, or does the buyer have a drop-off policy?

- **The subject matter.** Tailor your portfolio to suit the needs of potential clients. For instance, sending a portfolio with glamour photos to an industrial trade magazine is useless.

Editing Your Photos

The first task you have is to edit and organize your work. This may seem simple, but when it's done correctly, editing is extremely time consuming. You must put aside any personal bias you may have

toward certain images and concentrate on what sells. Select photos that buyers are interested in, even though some of the shots may not be your favorites.

It's not uncommon for photographers to have multiple portfolios. You might want to assemble several books based on the markets you intend to approach. Perhaps your work is split between editorial and advertising clients. Images that may interest an art director at an advertising firm may not appeal to a picture editor at a monthly magazine. When considering images to place in your portfolio, think about the buyers you intend to contact.

There are plenty of ways to find out what buyers want before assembling your portfolio:

- **Request guidelines.** Buyers use guidelines to explain the submission formats they prefer and give you a general idea of their needs. If you send away for guidelines, be certain to include an SASE. It might also be possible to acquire guidelines over the Internet simply by dropping a note via e-mail.

- **Review previous products.** This includes anything the clients have printed or produced in the past, such as previous editions of their magazines, advertisements, products on which they have used photography, books they've already published. Researching in this manner will give you a hint of what they prefer from photographers.

- **Read want lists that appear online or in photo industry newsletters and magazines.** Buyers often use these resources to list their current needs. You also can find out what buyers need in the listings of *Photographer's Market*.

- **Acquire editorial calendars.** Created annually by the editorial staffs of most magazines, editorial calendars describe in general terms what subjects are going to be covered in the coming year. They can be extremely helpful when trying to sell your work because you can see what stories a magazine plans to focus on. Therefore, you can submit images that fit with the magazine's themes for the coming year. Often, abbreviated versions of editorial calendars can be found in media kits that are sent to potential advertisers. Posing

as a potential advertiser might actually be the only way to get an editorial calendar, since most editors refuse to give them out for fear of leaking information to the competition. Therefore, reserve editorial calendar requests for those clients with whom you have a regular, solid working relationship.

• **Pay attention to the news.** News items that focus on company mergers or new product developments can help you discover photo needs.

Once you know what a client needs, you may discover that your files lack the images you need to submit. In those instances, complete self-assigned projects to create appropriate portfolio pieces. This will show initiative on your part and give you a more focused presentation in your portfolio.

Focus on the Best of the Best

As you distribute your portfolio, you will notice that buyers vary in what they prefer. Some may limit you to twelve to eighteen photos; others may be willing to review two slide trays. Trimming down a collection of thousands into a dozen portfolio-worthy photos can be

FIVE EDITING TIPS THAT WILL LAND YOU ASSIGNMENTS

• Constantly reinvent yourself. Whenever possible, show your newest work. Keep track of which images clients have seen, and avoid presenting the same material to them.

• Center your portfolio around one theme that speaks to the client's needs. This shows you're interested in solving her problems.

• Provide both black-and-white and color images to show range in your work.

• Always show your best work first. Never organize your portfolio with the intent of building up to your top images.

• Maintain an objective eye toward your photos, and be willing to accept criticism. The only way to improve your presentation is to learn from other professionals.

extremely difficult. The secret is to only show your best work and make sure the best of your best comes first. There's no need to build up to your top images with weaker photos; buyers will become disinterested if they must sift through bad photos to reach the good stuff. Remember that showing mediocre work to increase the number of images in your portfolio, or to add variety, will only hurt your chances of landing assignments.

If you're too close to your photos to maintain an objective eye while editing, hire a consultant or ask another professional photographer to help you. A consultant might cost you $100 or more per hour, but the expense of having an impartial person examine your work is worth it. Also, expect feedback about your portfolio from art buyers. They can give you numerous tips during a review for improving the overall presentation of your book.

This leads to an important point: Always be willing to accept criticism. No one has a lock on good ideas, and someone might just give you a suggestion that catapults your career forward. Don't assume that people who criticize your portfolio are slamming your abilities. If they care enough to make suggestions, chances are they see some talent worth developing.

Finally, if you intend to be present for the portfolio review (rather than dropping off your book), select images that have stories behind them. For example, maybe a certain assignment required quick thinking on your part to solve a problem. In the review, relate your story to the buyer to help build her confidence in your problem-solving abilities.

As you show your portfolio, remember to give suggestions about how your work can fit in with the client's needs. If you can make a buyer look good to his clients or boss, you can guarantee yourself future assignments and a permanent spot in the Rolodex.

Picking the Presentation Format

After editing your images, it's time to focus on presentation. What type of binder, box or case should you use to create your portfolio?

Are there any size limitations? Is it possible to create something that's both attractive and inexpensive?

First, buyers want a book that is manageable—nothing too large or hard to carry, especially if you intend to drop off your portfolio. No buyer wants to lug around a heavy portfolio, nor does he have the space for it. Limit your book to images that are 11×14 or smaller.

It is possible to put together a fairly inexpensive portfolio for less than seventy-five dollars. It depends on how extravagant you want to be, the size of the work and the overall content. However, this is one area in which you might want to pay extra for a more professional appearance. First impressions are important when approaching clients.

Bound and Unbound Portfolios

There are numerous options for presentation, and often it comes down to personal style and taste. Two common ways of showing your work are bound portfolios (such as spiral binders) and unbound portfolios (such as portfolio boxes). Each type has its advantages, so your selection should be based on what you're trying to accomplish.

Bound portfolios usually contain flimsy pages made of vinyl, acetate or Mylar. When placed on a table and opened like a book, the pages will stay open without being held. There usually is a sheet of black paper tucked inside each page. This provides a nice background for the images on both sides of the page.

Bound portfolios are great for showing images side by side, as in the case of spreads that have appeared in magazines. Perhaps you want to show similar styles. A bound portfolio allows you to easily group like images. The acetate sheets also protect your images from smudges. The downside of this type of presentation is that it's more difficult to change the order of your work.

Unbound portfolios, on the other hand, allow you to easily swap image positions. In a portfolio box, each photo is usually mounted and placed inside. The boxes lie flat when they are open, allowing you to individually remove each piece. Having the ability to add or remove images also allows you to easily amend the portfolio based on the client you're approaching.

Another benefit of unbound portfolios is that they force clients to review one image at a time. This keeps photos from competing against each other and gives you the chance to explain the details of each shot. When clients have two images in front of them, they may focus on one piece and ignore what you're saying about the other shot.

If you decide to store images in portfolio boxes, be certain the boxes are archival quality. The lining should contain acid-free paper in order to prevent deterioration of images. Store the boxes flat so the mounted pieces don't curl.

Both bound and unbound portfolios can be stored in handled carrying cases. These cases provide added protection and are extremely convenient when toting your work from client to client. Be certain to include your name, address and current phone number on your case. It also helps to place such information on the back of each portfolio piece. This is especially necessary when dropping off your portfolio. Pieces can become separated, and without knowing who owns the images, a buyer may inadvertently lose your work.

Presenting Transparencies

If you shoot with medium- or large-format cameras, you have several options for presenting images during portfolio reviews. You could place each photo inside a plastic sleeve and show your work on a lightbox. You might decide to manufacture prints from your transparencies and then mount each image. Perhaps, digitally scanning your photos and placing them on a CD-ROM appeals to you.

However, one simple and attractive way to present transparencies is to frame each image between two mats. Once each portfolio piece is properly created, it can be shown on top of a lightbox. This form of presentation works well for formats 2¼" or larger. It can be done with 35mm slides if you intend to show one or two images, but 35mm is a small format and doesn't lend itself to this type of presentation for an entire portfolio.

Premade mats, specifically designed to hold transparancies, can be purchased from retailers for four to five dollars per frame. The cost will depend on the quantity, quality and size. If you're a do-it-yourselfer, you can make your own for less money.

Sample Bound Portfolio

Photos on pages 71 and 72 courtesy of Light Impressions, Corp., P.O. Box 940, 439 Monroe Ave., Rochester, NY 14603-0940. Call (800) 828-6216 to request a free catalog or place an order.

A spiral-bound presentation book might serve you well when showcasing photo essays or a consistent theme in your portfolio. With such a book, don't place vertical images beside horizontals. This can be annoying to the viewer who is forced to rotate the book 90 degrees in order to see each image.

Sample Unbound Portfolio

A carrying case shows professionalism and protects your work when images are dropped off. An unbound presentation allows you to easily amend your portfolio and forces buyers to review images one at a time.

Making Your Own Mats

First, select two pieces of black mat board that cover the top of your lightbox. (You may opt to use white or a light gray for your mat boards; however, black hides any dirt or fingerprints that may get on them.) The edges of the boards should extend just beyond the border of the lighted surface. This will prevent light from creeping beneath the outer edges. Use a mat cutter to cut holes in the middle of each mat board. The holes should be cut to a size one-fourth inch smaller than your transparencies. In other words, if you shoot 4×5 film, cut rectangles in the center of each mat that are $3\frac{3}{4} \times 4\frac{3}{4}$.

Place one of the mats flat on a table and set your transparency face down over the hole you cut. Place half-inch-thick, black tape over the edges of the transparency to prevent excess light from escaping. Be sure you are taping the back side of your transparency. Also, the tape should not drop below the cutout border of the mat frame, or the tape will show when the image is laid on the lightbox. To protect the transparency, keep it enclosed in a clear plastic sheet that has been cleaned to guarantee that the image quality still shines through.

On the second mat board, tape a thin piece of frosted paper over the hole in the center. When the two boards are placed together, the paper will hide unsightly scratches on your lightbox and give you a soft even lighting beneath the image.

Now you are ready to join the two pieces of mat board. This can be done in several ways, by applying rubber cement, dry mount spray or double-sided tape. Apply the adhesive of choice on the inside portion of one mat board. Keep the adhesive to the outside of the frame, being certain not to stick anything on your photo. Press the two sides together to seal the frame.

Slide Trays and Lightboxes

Many photographers shoot with 35mm cameras, but slides are small and can't be viewed easily without some sort of enlargement. Rather than having clients look through a loupe to see 35mm images, you might dupe slides up to larger size. Or you can show them on a screen using a slide projector.

However, before you load up a slide tray, be certain the client approves of such presentation. She may not have the space for a slide show or may not even have a projector handy. If you call and gain approval for a slide presentation, ask how many images to include. Trays hold dozens of slides, and you don't want to show eighty images if the client only has time for twenty.

While the client may have a slide projector, consider bringing your own. You'll be more familiar with the equipment and will be assured the projector is working. Also, this eliminates the possibility of someone on the client's staff using the projector when you need it for the review. Plus you can prepare for that ill-fated moment when the projector's lightbulb blows by having a spare handy.

When organizing the tray, as with prints or larger transparencies, be certain to start with your best work.

As mentioned previously, lightboxes can be a great way to show off your photos. Like projectors, bringing your own lightbox might be easier than relying on the client. You can prepare your matted frames to fit the entire top, and you'll guarantee that the lightbox is available when it's time for the review.

Electronic Presentation

Finally, there are several ways to present your work in an electronic format, such as diskettes, CD-ROMs and through online networks. So far, there have been mixed reactions from clients to digital presentation. Some find web sites or CD-ROMs extremely helpful when seeking out new talent; others have no use for the growing technology. The same is true for photographers: Some have had success with this type of marketing; others have not.

If you're researching digital formats, you have several decisions to

make before plunging in. And all of your decisions should be based on one question to yourself: "What's the return on my investment?" It's great to show clients you are up with the times by presenting them with digital imagery. But be certain the money and time you invest in creating a CD-ROM or web site is well spent.

What follows is a list of details to consider when investigating electronic presentation:

- So far, few photographers are making money with their web sites. While the World Wide Web gives photographers a new promotional tool, few new clients are found this way. The Web is just too large, and photo buyers aren't interested in wading through the junk to find quality imagery.

- While digital imagery has grown in popularity, the image quality does not compare to traditional film. Don't plan to discard your print portfolios in exchange for electronic presentation of your work. Often, clients will use digital presentation as a stepping stone to your regular portfolio.

- Do your clients, or those you plan to approach, have CD-ROM capabilities or access to the Internet? Nothing would be worse than investing time and money into going digital and then discovering your clients aren't up to speed technologically.

- If clients have CD-ROM drives, what are their computers' specifications? Are they using Macs or PCs? How much memory do their computers have?

- How do you plan to get your work into digital format? Two common options are digital cameras and scanners. When researching digital cameras, consider the final application of the images once they are captured electronically. If you plan to place them online or on a CD-ROM solely for promotional purposes, a low-end digital camera might suit your needs. These cameras typically offer a lower resolution of around 200 dpi and cost less than $1,000. However, the image quality is unsuitable for publication, especially if you plan to crop and enlarge portions of images. If you intend

to use the images for publication, you'll need a high-end digital camera that could cost $10,000 to $30,000. And if you acquire a high-end digital camera, you need to consider the memory capacity of your computer. Digital images, even ones that have been compressed, take up a lot of space on your hard drive. You must be certain the image files can be properly stored.

A scanner is a less expensive way to convert film-based images into digital format. You can purchase top-quality scanners for less than $500, or you can have a service bureau scan the images for you.

• Which online service is going to give you maximum exposure? And how are you going to promote your web site? This is key. If clients don't know you're online, then having a site really doesn't matter. Make sure you register your site with as many Web browsers as possible. Send out promo cards, news releases or e-mail to clients, giving them your Web address.

• Who's going to design your web site or CD-ROM? It's fairly simple to learn hypertext markup language (HTML) in order to create your own Web page. HTML is the programming language needed to link images, pages and sites on the Internet. If you aren't comfortable doing it yourself, or don't have the time, you can work with a designer who specializes in Web page creation.

If you decide to create your own Web page, review sites already on the Internet. Studying other sites will help you select features for your own page and give you a better understanding of what clients prefer when visiting a web site.

Sample Portfolio

There are as many opinions about portfolios as there are art directors who review them. You may already have a book that you feel pretty good about—one that has resulted in wonderful feedback and maybe some assignments. Or, possibly, you're on the other side of the scale—having trouble selecting images that interest buyers. Whatever your situation, the following pages should help you during the editing process.

I asked a colleague, Sam A. Marshall of Cincinnati, Ohio, to lend me his portfolio to show you what makes a portfolio strong. He put together a general-purpose book that contains work from his career as a photographer and journalist. The images are varied in content, but all are included with a purpose, as you will read in my discussion with Sam.

Sam began work in photography by producing photo illustration for his news and magazine articles in the early 1980s. Past clients have included *Cincinnati Medicine*, *Toastmaster* magazine, *Entertainer* magazine, *River City Music News* and the *Cincinnati Post*. In 1996, he became a board member for Images Center for Photography, a Cincinnati-based independent, nonprofit organization dedicated to promoting appreciation of photography throughout southwestern Ohio. In 1995, he served as official photographer for the two-day musical festival "Pepsi Jammin' on Main" held in Cincinnati. Also in 1995 he received a Merit Award from the Art Director's Club of Cincinnati for an editorial illustration that first appeared on the cover of a local alternative newspaper, *Everybody's News*.

Photo by Kathy Marshall

Sam Marshall

Sam regularly exhibits his work throughout Cincinnati at local shows and art spaces including the Hyde Park Art Show, the Montgomery Art Show, the Cincinnati Nature Center Members' Show, Norton Photography and Images Center for Photography.

My guess is that many of you are in a similar position as Sam, working regionally to build your client base with hopes of broadening to national markets. Hopefully, his insight will give you some guidance and a few ideas for your own portfolio.

Why did you organize your portfolio in this manner?

I have a mixture of photojournalism, fine art and portraiture pieces. There's alternating perspective where you see a subject from a distance and then you have a tight shot. Some of it's close detail, some of it's a tight silhouette of a subject. I like to vary composition and switch from black and white to color so there's always something fresh. I also alternate animate and inanimate subjects.

There's one page with three images on it. I got that idea from [photo rep] Elyse Weissberg. She referred to a photographer on a low budget who shot one subject a lot and used smaller pictures to show different perspectives or approaches to the same subject. In my book I used one page as an overview of Tall Stacks in Cincinnati. This format allowed me to show a woman in period costume and then give an overview of the event along with a close-up detail of a paddle wheel.

What I've really been shooting for the past two or three years as a personal assignment has been musical performers and theatrical people. Therefore, I'm alternating performers and still lifes in this portfolio. That's a conscious decision to provide action and then repose.

So the variation in subjects and pacing is something you really want art directors to think about. Do they ever get bothered by the diversity?

I've never had anyone comment that they've found it distracting. A vertical composition beside something horizontal can be distracting. If you have a horizontal, art directors like to see it run across the page so they don't have to continuously turn the book.

Is there a reason you chose a spiral-bound format for your portfolio rather than an unbound format?

I like the styling of this book and the fact that it was zippered. I was looking at some others, but this had a more contemporary feel. There are some problems with it, though. If your mat is a little too wide, it pushes against the spirals and sometimes the plastic gets caught in the teeth. Even though they're together, it catches and the pages

don't turn freely. So I cut the mats a little shorter. What I was looking for was the ability to switch my mats from the portfolio to frames so I could use them in my exhibits. The spiral-bound format is flexible enough to do that.

All these images are on a white background, as opposed to a dark background. Is this intentional?

Yes. This portfolio comes with black construction paper pages that sit between the plastic, and you can mount pictures on them for a black background. Since I use mounts for my portfolio and for exhibitions, I wanted them to have a clean, consistent look. It's really a matter of preference.

How many images do you recommend for a portfolio?

What I have here is a tight edit of eleven pictures. I think ten to twenty is a maximum range. You want to eliminate your weakest shots for any portfolio. I like to open with a strong photo and have a good pacing throughout, mixing formats, content and composition. Then I like to have a strong closing.

Also, while you can start with the right-hand page and end with the left-hand page, I prefer to start on the right side and end on the right side. That way the last picture you see is facing out without having to turn the page. That's why I have eleven pages here.

How would you change this portfolio depending on who you're approaching?

This is a general-purpose book. Obviously when I know I'm going to present to someone in particular I take out things that may not appeal to them. If I was going to submit to a magazine to show general subject matter, I'd probably take out the musicians and show more of my architectural work and landscapes. If I was submitting to a travel magazine, I'd show more documentation and observation pieces with people.

When I went down to the *Cincinnati Enquirer*, I concentrated mostly on showing them entertainment and the arts. I wasn't interested in shooting sports or fires or anything else. But they said I needed

to show some food and fashion, some tabletop, because they want freelancers who can do it all. I got favorable feedback on what I showed, but they wanted someone who could cover anything. So if you're dealing with general news publications, you have to show a lot of subjects.

I noticed your portfolio also shows your ability to use different techniques, such as masking and shooting photograms.
I have a mixture of location and darkroom effects. Some of it is manipulated and some is just photojournalism. I wanted buyers to see that I can use different techniques. Some of these pictures aren't perfect, but they're representative of certain periods in my shooting. I'm trying to show more observations through subject matter, hoping I can connect with potential buyers.

The Submission

Chapter 7

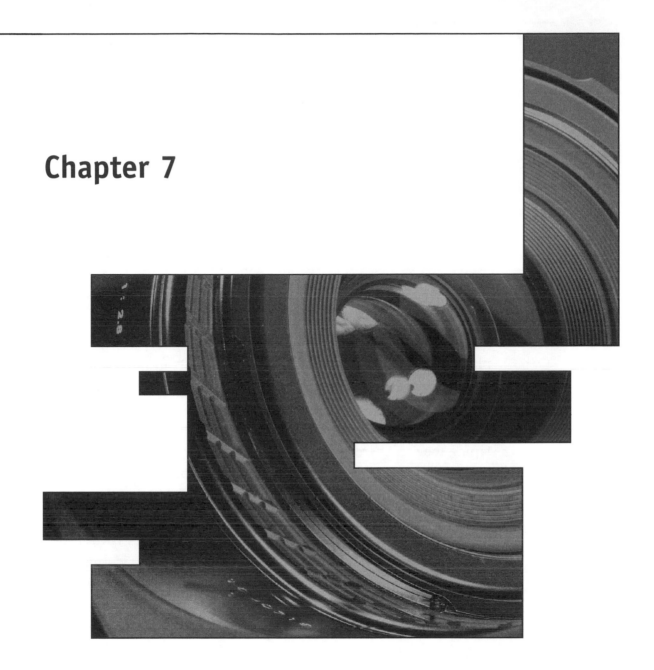

Preparing Your Submission

Chapters one and two discussed the various components of your submissions. Now I'll address the submission packages themselves. Exactly what is the best way to package your work for potential buyers?

First of all, it's extremely important to protect your photos from physical damage in the mail. Some recommended safeguards in this chapter may seem like a lot of effort and may cost extra money, but the most important thing is to guarantee the safety of your work during transport. This is especially true for originals, which, if damaged, are lost forever.

When mailing slides, prints or transparencies, it's best to place them inside plastic sheets and then tuck the sheets between two sturdy pieces of cardboard. Your local camera shop should stock plenty of plastic sheets that accommodate all sizes of prints and transparencies. Usually a package of one hundred archival-quality plastic pages can be purchased for under twenty-five dollars.

After sandwiching images between the pieces of cardboard, avoid taping the cardboard together. Tape may inadvertently stick to your photos during transport. Instead, use two rubber bands to hold the pieces together.

If you specialize in 35mm photography, you might want to purchase Kimac slide protectors. Kimacs are thin plastic sleeves (two inches square) that fit snugly around individual slides. For added protection when mailing images, place Kimacs around each slide and then place your photos inside the slide sheets. That way, if a photo editor removes a slide from the acetate sheet, the Kimac will shield the image from dirt, dust and fingerprints. Please note: If you use Kimacs, do not place labels on them rather than the slide mounts. Kimacs can be removed from images, and without identification, no one will know whose images they are.

With all submissions, enclose delivery memos that detail the contents of your submissions. Sample delivery memos can be found in chapter one. Also include cover letters or query letters that introduce your work to photo buyers. For more on writing query and cover letters, see chapters eight and nine.

Client Lists, Stock Lists and Bios

When sending your submission, show buyers you have experience as a professional photographer. Three simple tools to do this are client lists, stock lists and bios.

As the name implies, the client list provides the names of past buyers of your freelancing services. Obviously, this list should feature major accounts, such as national magazines, large book-publishing houses and distinguished advertising firms. However, if you only have a few clients, don't fret. List as many clients as possible. The important thing is to show buyers you are serious and have some sort of track record.

If you are a stock photographer, your experience can shine through by detailing the images you have photographed. Buyers love to know what photographs they have access to, but they don't like storing thousands of images—that's why stock agencies exist. Instead, buyers prefer stock lists, which essentially describe the subjects you have photographed. With this list, itemize as many subjects as possible in great detail. For example, if you're a nature photographer, tell what animals you have photographed, including the species names. (Don't just state you have photos of wildlife.) Then buyers can review your stock list if they need images. For an example of a detailed stock list, turn to pages 117-118.

If you don't have a large client list, a bio can be just as helpful. The bio is basically a paragraph or two that details the important aspects of your working career. This can include any awards you've won, length of time working as a professional photographer or a summary of freelancing credits. Send it along with your stock list and the rest of your submission package.

On bios, it also doesn't hurt to include testimonials from clients. Your list of clients might be short, but if you have a good working relationship with a few buyers, they should be willing to plug your talents and allow you to use their comments for promotional purposes.

Mailing the Package

Inside your submission, always include an SASE for return of your images. Many buyers require freelancers to send SASEs for any

Sample Photographer Bio

Cite length of time as
a professional
photographer.

Cite area of specialty.

Cite past awards.

Include testimonials.

Austin Seigel of West Chester, Ohio, has been a professional photographer for more than 10 years, working almost exclusively in landscape and wildlife photography. His photos have earned him honors from the National Landscape Photographers Association, The American Wildlife Management Society and The National Animal Protection League. His images have graced the covers of numerous wildlife magazines, including *Chipmunks Today* and *Water Buffaloes Weekly*.

"Austin is one of the most creative photographers I've ever worked with. He brings unparalleled vision to every assignment."

—Max Casey, Sunshine Cards

"Austin is fabulous. How can you go wrong with a guy who is willing to go the extra mile to meet deadlines and tackle assignments that other photographers aren't willing to complete?"

—Francine Walsh, *Chipmunks Today*

To guarantee that your submission is ready for mailing, check to see that it contains:

- A query letter or cover letter properly addressed to a current contact who works for the prospective client.
- Sample imagery, such as slides, prints or a self-promotion piece.
- A delivery memo (when you send actual photos).
- A stock list, client list or bio (optional).
- A self-addressed, stamped envelope (SASE) for return of your images or a reply from the client.

material that should be returned. Simply stick adequate postage on an envelope and place it inside the package with the photos. (When mailing a package to countries other than your own, you will need to purchase International Reply Coupons and affix these instead of stamps to the outside of your return envelopes.) If you don't enclose return envelopes, uninterested buyers may not return your images.

Once submissions are ready for shipment, be certain they can be traced. Mailing them via first-class mail is not enough. You must be able to track the package if it gets lost in transit. Several courier services assign numbers to packages so they can be easily tracked: Federal Express and United Parcel Service (UPS) are two of the more commonly used companies. You can also consider sending your images via certified mail through the U.S. Postal Service. All of these services require recipients to sign for packages.

As added protection for your images, consider using padded envelopes or those lined with bubble wrap when mailing photos. Some

POSTAGE FEES

It's important to note that many photographers, especially those working on assignment, bill clients for mailing expenses. Unless you are submitting work on speculation, don't consider courier service fees to be a part of your expenses as a businessperson. Pass these costs on to clients whenever possible.

photographers prefer stiff cardboard mailers or even thin boxes. You can use paper envelopes, but the only protection for your images will be the cardboard inside.

On the outside of your photo submission package, it's good to write or stamp the following: "Hand Cancel," which keeps packages from being sent through machines at the post office, and "Photos Enclosed, Do Not Bend." You might want to write these phrases in several locations, and don't forget to include them on your SASEs.

Liability for Lost or Damaged Images

As discussed in chapter one, clients must understand the value of your photos. If original transparencies or negatives are damaged or lost, you miss out on future sales. Make sure clients understand that they are to inspect the images when they arrive, and have them sign and return a copy of your delivery memo to guarantee all images are accounted for and unblemished. If damage occurs during shipping, they must notify you immediately.

So who is liable if something bad happens to your work in transit? Once a client signs and returns your delivery memo, he is responsible for the well-being of your images until you have them safely in hand. It is the client's responsibility to properly repackage and return your work. His responsibility does not end when he hands the package to a mail carrier. State this on your delivery memo so there is no confusion. It's also wise to require clients to return images via Federal Express, UPS or certified mail.

Unfortunately, if images are damaged or lost, it's impossible to recover lost income from future sales. Since there is no way of knowing how much money can be made off any photo, most insurance companies will only pay for the cost of replacing the film if images are destroyed or lost. They consider the market value of images "intangible" and, therefore, uninsurable.

Even the courier services offer limited insurance for photography. For example, Federal Express, according to its Service Guide, allows a maximum of $500 for photo negatives, slides, chromes, limited edition prints and "any other commodity that by its inherent nature

is particularly susceptible to damage, or the market value of which is particularly variable or difficult to ascertain." So be certain you understand any liability limitations that are placed on the packages you mail.

Selecting and Working With a Market

Up until this point, discussions have been limited to the proper methods of conducting business. I've shown you examples of the forms you will use, talked about methods of promoting your work and, in general, covered the proper ways to package and sell your talents. Now it's time to put those ideas into practice.

The following chapters discuss the more obvious places where you can sell your work—magazine publishers, book publishers, commercial clients, paper product/gift producers and galleries. You'll learn a little bit about each market, how to approach new clients in each area and what buyers in each field want to see from photographers. Each of these markets has a unique audience and, therefore, requires a slightly different approach from photographers interested in selling their work. Therefore, I also provide sample query and cover letters and more forms that help with your everyday office tasks.

Remember that the markets you approach really should depend on your style and area of interest. You may have the desire to shoot fashion for advertisements or portraits for corporate brochures, in which case the commercial field will serve you nicely. Perhaps you're interested in covering world events or traveling and documenting the places you visit. In these instances, consider magazines, book publishers and paper product companies, which are always searching for quality work.

It should be pointed out that these obviously are not the only markets for your work. There are other more specialized markets for your photos, and many of them pay handsomely and buy lots of photographs. The markets in this section, however, are well established and provide steady income for thousands of photographers annually.

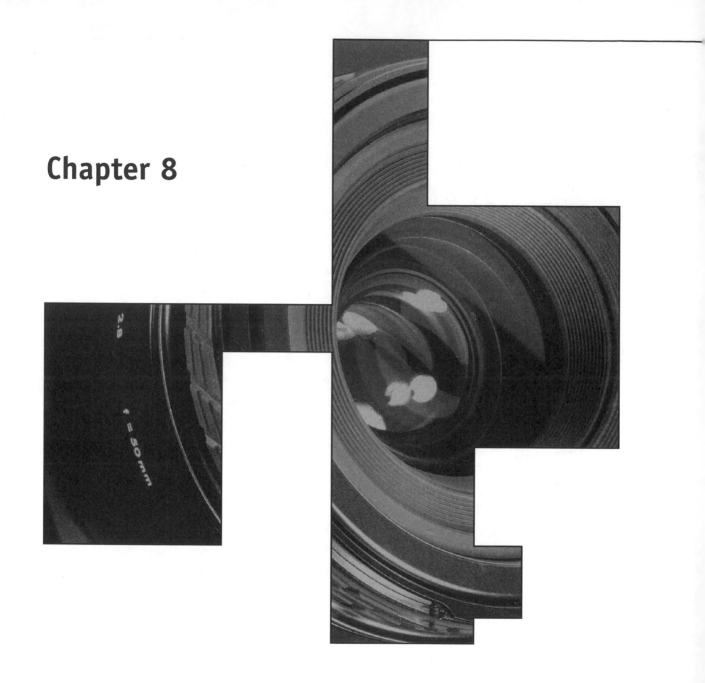

Chapter 8

Magazine Publishers

In the magazine world, headaches arise for photo buyers in several ways. A picture editor might need a photographer for quick assignments—someone she can trust to meet deadlines without a lot of questions. Perhaps a feature story requires a stock image, but the photo editor is uncertain where to get it. The scenarios are endless. The key is to have editors think of you when they're seeking solutions.

In this chapter, you will learn how to approach magazine markets, either with stock images or in an attempt to garner assignments. Basically, there are three ways to make initial contact: the telephone, cover letters and query letters, and portfolio presentations.

Working the Phones

Picture editors, art directors and photo editors work under heavy deadline pressures. The last thing they want is an unknown photographer calling them on deadline to give a sales pitch. So how can you break down this barrier? A little foresight can make this initial contact worthwhile.

- **Know who buys the photos and assigns projects.** Magazine staff members are listed on the masthead inside most magazines. Find the names of current photo editors, picture editors or art directors. By knowing who to contact, you will keep yourself from being forwarded by company operators to the wrong people.

- **Learn deadline schedules.** As mentioned previously, buyers hate deadline interruptions. Call and talk to receptionists or assistants to find out deadline schedules. (There's no need to bother photo buyers for this information.) For example, many of the weekly magazines go to press each weekend, so don't call on Thursdays or Fridays. Buyers will give you more time over the telephone if they aren't busy.

- **Keep your telephone discussions brief.** Have a few basic topics to cover, such as the following:
 1. What types of stock images does a buyer prefer?
 2. What about formats (e.g., slides, prints, CD-ROM, etc.)?

One quick tip: When dropping off a portfolio, place a Post-it Note on the fifth or sixth page of your portfolio. On the note write something like, "If you get to this page, please remove this Post-it Note." Some buyers get too busy to review portfolios, and this is an easy way to know whether your work was actually reviewed. When you discover that your portfolio was not reviewed, wait a couple weeks, then call and ask buyers to take a second look. Explain that you've added a few new pieces you think they might like. Knowing they didn't see your work the first time, they invariably agree to take a second look. And the note usually disappears the second time around.

3. Get the correct spelling of the buyer's name and title and an accurate mailing address for submissions. Misspelled names show a lack of professionalism, and incorrect addresses can waste postage.

4. Ask if the buyer has a drop-off policy for portfolios. A drop-off policy is a system in which photographers leave their portfolios with buyers on established days. For example, magazines may ask that portfolios be dropped off on Tuesday mornings and picked up on Wednesday mornings. Drop-off policies mainly exist at larger magazines because they receive so many portfolios. If you want to work with a magazine in a distant city, state or country, ship your portfolio via registered mail. Drop-off policies exist for people who want to visit buyers in person, but they aren't meant to discourage out-of-towners.

Query Letters and Cover Letters

These letters are similar in that often they are the first contact you will have with photo buyers. And, as the saying goes, you never get a second chance to make a first impression. Make that impression a good one. Some buyers receive dozens of submissions each month, so it's imperative for these letters to be snappy, well written and to the point.

Before you send any correspondence, familiarize yourself with magazines you plan to approach. Read current and back issues to grasp the editorial content. This will keep you from submitting ideas that appeared in previous issues. And always make sure you know the person to whom your letter should be mailed.

The query letter is used mainly as a tool for writers who have story ideas to sell, but it can be used by photographers who want to pitch photo essays or photo-text packages. And when you pitch your ideas, make sure they are mentioned immediately, in the first sentence or two. Don't save your ideas until the end of your query letters. Also, keep letters to magazines brief, no more than a page each.

In the sample query letter on page 105, note several points:

• The beginning sentence mentions the fact that I'm familiar with the publication. This lets the buyer know I understand the editorial content of her publication and, therefore, can service her magazine's needs.

• The next paragraph immediately presents the story idea, but it also makes reference to the magazine's readers. Demographics such as the age, gender and economic status of readers often can be found in media kits (see sidebar, page 104). When you're interested in approaching a magazine, call and request a media kit before submitting work. This will help you fine-tune your submission.

• The third paragraph lets the buyer know I'm an experienced professional, and the attached list of past clients and awards will verify my skills.

• The closing calls for some kind of future interaction between myself and the buyer. It doesn't say I expect the buyer to contact me immediately, and it leaves the door open for me to call her.

The content of your cover letter depends on the goal of your mailing. If you are sending a package of stock images, the cover letter should confirm the number of images enclosed, state an expected fee for usage and specify the rights to the images you are willing to sell. The

Media kits can teach you a lot about publications. Used mainly as a tool to help advertisers learn about readers, media kits provide plenty of information that can be useful to a photographer. Media kits routinely provide reader demographics, brief editorial calendars that tell what subjects are being covered in future issues, photography and writing guildelines, and advertising rates. The more you know about a magazine, the more you can fine-tune your submission to suit the editor's needs.

cover letter also can be used to request a portfolio review in order to gain assignments.

In the sample cover letter on page 106, consider these points:

• You might think this letter doubles as a delivery memo because it states the contents (40 slides). However, delivery memos are far more specific. They list images by their filing codes and require clients to acknowledge receipt of photographs and assume liability for lost or damaged work. Don't forgo a delivery memo even if you state the submission contents in your letter.

• Like the query letter, the cover letter states in the first paragraph that I know something about the magazine. Buyers appreciate research and are more willing to work with freelancers who understand their audience.

• Unlike the query letter, this cover letter does not list credentials. I plan to provide this information separately—through use of a bio and client list. For more on these turn to page 95.

• Since I'm sending sample images I want the buyer to know I still own the copyrights and they are not allowed to use these images until we've negotiated a fee. I note this in the postscript (P.S.) so that I don't clog up the main contents of letter with legal issues.

Sample Query Letter for Magazines

February 27, 1997

Michael Willins
7016 Ragland Road
Cincinnati, OH 45244-3110
(513) 561-6044

Jenny Carmichael　　　　　◄──────────────────────── Current contact.
Then & Now Magazine
732 Main Street
San Francisco, CA 94113

Dear Ms. Carmichael:　◄──────────────────────── Salutation.

In recent weeks I've reviewed past editions of *Then & Now Magazine* and developed a story idea that is perfect for its pages. ◄──── Cite knowledge of magazine.

Ever since they were created, the Little Rascals TV characters have been enjoyed by millions of people, young and old. I know that 65% of *Then & Now*'s readers range in age from 60 to 75, and I'm certain they would love to see what the show's cast members are doing today. My idea is to photograph the core members and provide short bios that explain what happened in each character's career since leaving the show. ◄──── State assignment concept.

Enclosed are photos from past assignments I've completed that should give you a sample of my photographic skills. Please return them in the enclosed SASE when you are through reviewing them. I've also enclosed a list of previous clients and photographic awards I've earned. ◄──── Provide samples of past work.

May I discuss this idea with you in the coming weeks?

I look forward to your reply.

Best regards,

Michael Willins
Writer/Photographer

This serves to introduce a story idea and submit sample images.

Sample Cover Letter for Magazines

February 27, 1997

Michael Willins
7016 Ragland Road
Cincinnati, OH 45244-3110
(513) 561-6044

Current contact. ———→ Jenny Carmichael
Then & Now Magazine
732 Main Street
San Francisco, CA 94113

Dear Ms. Carmichael:

Confirm number of images submitted. ——→ Enclosed you will find 40 color slides for your consideration. Since your magazine focuses on historical places and well-known personalities of yesteryear, I thought you might be interested in reviewing photos of gold mining towns that popped up in the late 1800s.

Cite knowledge of market.

State usage concept. ——→ Five or six of these images with captions would make for an excellent photo essay in a future edition of *Then & Now Magazine*. I could provide captions once you select the photos you want to use.

Always provide SASE. ——→ I've enclosed an SASE for your response and look forward to hearing from you in the coming weeks.

Best regards,

Michael Willins
Writer/Photographer

Provide disclaimer regarding image usage. ——→ P.S. Please note that this submission is for reviewing purposes only. No rights are granted for image usage until an appropriate fee and usage rights are negotiated.

This is sent with a stock submission or request for portfolio review.

Portfolio Presentations

After you have attracted the attention of a photo buyer with your direct-mail pieces, you may be asked to submit your portfolio or come in for a portfolio review. Usually this means the buyer likes your style and is considering you for assignments. The review gives buyers a chance to see your talents in greater detail—for example, the types of subjects you shoot, how you control lighting and whether you work better in black and white or color.

When it comes to reviewing portfolios, you will find that buyers vary widely in what they prefer. Some like slides; others want mounted prints. The one consistent theme is that all buyers want to see great work. They may like an organized, attractive-looking portfolio, but content is key.

While showing your work, concentrate on selling yourself. What do you have to offer that the client can't get from someone else? Are you good at meeting deadlines? Do you relate well to people? Perhaps you love to experiment with various printing techniques. It's also a good idea to discuss how shots were taken. Note instances when you encountered problems on assignments and explain how you solved them for clients. Any positive aspect of your work habits that could sway a client into hiring you should be brought up during the presentation.

As you prepare for presentations with photo buyers at magazines, there are several points to consider:

- Although it's good to have a standard portfolio to show on a moment's notice, study each magazine with which you want to work. Then tailor your portfolio to each client based on the magazine content. For example, don't waste time showing a portfolio of nature and landscape photos to a science trade magazine.

- What presentation format is favored? Do they like slides or larger transparencies? What about prints, CD-ROM or online network presentation? You might face resistance to some formats simply because buyers are not equipped to handle them. Not every picture editor has access to a CD-ROM drive, or even a slide projector.

• Do they want to see a small number of images, such as twelve to fifteen prints, or is a tray with seventy to eighty slides OK? Show only your best work, and make sure the best of your best comes first. Don't build up to your top images with weaker photos. Buyers may become disinterested. Remember that showing mediocre work to increase the number of images in your portfolio, or to add variety, will only hurt your chances of landing assignments.

• Are they interested in seeing one consistent style, or do they prefer numerous styles that show your diversity?

• Remember to bring a self-promotion piece to your portfolio reviews so you can leave something with the clients. This gives them something to which they can refer when they are trying to remember your style.

Probably the most important aspect of the portfolio process is to get feedback. Never leave a portfolio review without knowing where you stand. Is the client interested in your work? Does he have assignments for you? Perhaps there's a project coming up in the near future for which you are perfect.

If photo buyers decided not to hire you, find out what it was that turned them off. Do they have any suggestions for improving your portfolio? Perhaps you need to add more black-and-white photos or more color. Maybe they think the subjects were too varied. Whatever they tell you, remain open-minded. Not everyone is going to like what you show them. The important thing is to listen to others' advice and act upon it, because eventually this will lead to new clients. For more on overall presentation of your portfolio, turn back to chapter six.

Stock Submissions

Until now I've talked mainly about attracting assignments from magazine clients. However, stock image sales also can bring in a steady income. Actually, many picture editors turn first to stock when they are seeking imagery for magazine articles or covers. They search

through stock catalogs, clip art discs, and stock lists and submissions from freelancers.

The trick to selling stock to magazines is knowing what photos editors need and when they need them. Timing is crucial. Sometimes these needs can be uncovered through a little research; at other times sales occur because images submitted on speculation just happen to cross a buyer's desk at the right time. If you can marry the two ideas of timing and research and plan your mailings accordingly, you will sell plenty of stock images.

There are numerous ways to find out what magazines need. One way is to search through photo industry newsletters, such as *Photo Stock Notes* (PhotoSource International, Pine Lake Farm, 1910 Thirty-fifth Rd., Osceola, WI 54020) and *The Guilfoyle Report* (AG Editions, 41 Union Square W., #523, New York, NY 10003). Many buyers list their photo needs and deadlines inside newsletters when they are searching for specific material from freelancers. Similar listings that provide buyer needs can be found in the annual directory *Photographer's Market*.

You also can get a jump on the competition by knowing the yearly editorial schedule of magazines. Some periodicals designate certain months for established annual issues. If you know the themes of these issues, you can schedule your submissions based on those needs. Remember, most monthly magazines work several months in advance, so plan your submissions accordingly. Don't expect to approach a sports magazine in November with photos for its yearly skiing issue in December.

Some other ideas for finding out magazine photo needs:

• **Cold calling.** A quick phone call to an editor might help you uncover an upcoming project or two. This works especially well when contacting clients with whom you've already completed assignments.

• **Reading magazines and newspapers.** The media is a great place to find out what's happening with magazines. Some editors discuss changes in their editorial direction or trends relating to their publications, and these tidbits can help when landing assignments.

As mentioned earlier, photo buyers also review stock lists when they are in a pinch and searching for specific imagery. They can't always find what they need through stock agencies, and if they have your stock list on file, they might contact you to request submissions. If you have a large number of images, be sure to develop a list of what's available and mail this list with submissions. Buyers might not be interested in the images you've sent, but they might like to see something else in your files. To review a sample stock list, turn to pages 117-118.

Chapter 9

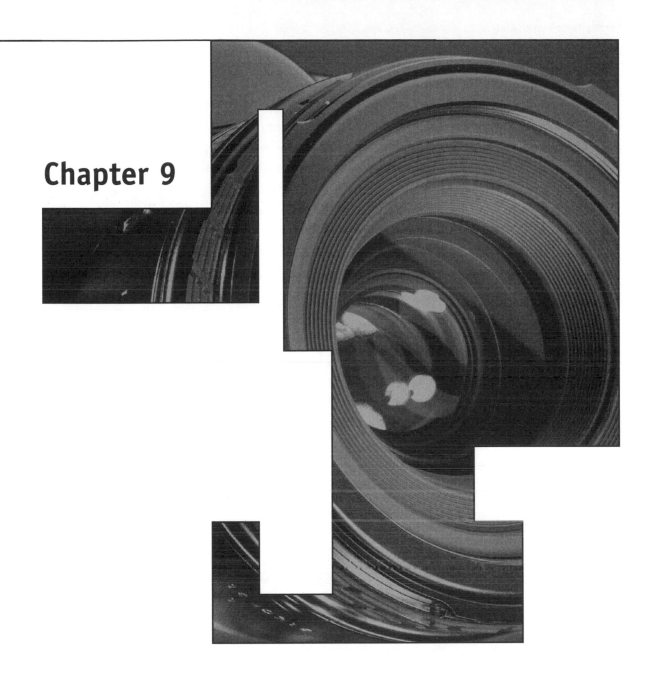

Book Publishers

If you regularly browse the photography sections of bookstores and libraries, you've noticed a plethora of titles by the masters—Richard Avedon, Mary Ellen Mark, Herb Ritts, Gordon Parks and Ansel Adams, to name a few. The well-known photographers are the ones who dominate the shelves, and you might wonder if it's possible to have your own book sitting beside those of such famed shooters. In reality, anyone with a great idea can find a publisher.

For photographers, there are two ways to garner sales with book publishers. The most common route is through sales of individual images that are used to illustrate the contents of books. Often, publishers purchase stock images to fill their needs; however, some assignments can be had. Because most publishers need photos for text illustration, this is the best way to break into unfamiliar markets. And, believe it or not, you likely will make more money selling single images than entire books of your work.

Photo books, also known as coffee-table books, are another way to work with publishers. Although few publishers produce photo books, it is this type of presentation toward which most photographers strive. Books allow photographers to portray subjects with great depth.

Ideas for coffee-table books, however, are hard to sell, mainly because they are not high-volume titles. Publishers often run only five-thousand to ten-thousand copies of such books and pay high production costs for image separations and quality paper stock. These books, therefore, are typically priced at forty to fifty dollars to allow publishers to recover their expenses. Unfortunately, the prices make coffee-table books too expensive for the average book buyer, so don't expect to get rich from them.

Before signing a book contract, it's important to understand how the industry works. For the publisher, there are numerous variables to consider, such as production costs, potential sales outlets and distribution. It's likely that one or more of these variables will have some impact on the editorial content of your project. Quite often, in fact, the sales reps with whom the publisher works have some influence on book covers and content. After all, the sales reps are the ones who deal directly with buyers, and they know what the public prefers.

Therefore, don't be discouraged if an editor trims a few images you think are fabulous. Don't get angry if your idea of a cover photo is different from the publisher's. You must be willing to give up some editorial control. Besides, nobody benefits from a book that does not sell, and editors merely want to improve the finished product.

Study the Publishers

Before approaching a new client, there are a couple preliminary steps to follow to improve your sales potential.

First, acquire catalogs for those publishers you plan to approach. If you have access to the World Wide Web, it's also possible to locate publishers online. How are their titles represented? Are the images in black and white or color? Do they show covers in their catalogs, or do they simply give brief descriptions? What photographers have they worked with on previous titles? This kind of information can give you an understanding of how your images will be used. Plus, it helps when establishing prices for your photos.

Next, visit a local bookstore or library to see titles publishers produce. Such research will help you evaluate publishers based on the subjects they cover. For instance, if you specialize in food photography, stop by the cooking section to see who is producing cookbooks or guides for healthy eating. These companies likely will be most interested in your work.

Reviewing current titles also will help you locate those publishers who produce shoddy material. Poor image reproduction or low-grade paper, for example, might indicate that a publisher has a minimal budget for production and, therefore, won't be willing to spend money on good photography. Avoid working with buyers who won't place your work in the best light.

Finally, be certain each submission is directed to a specific image buyer, and always double-check the spelling of contact names. You might find some of this information in *Literary Market Place* (R.R. Bowker's annual directory of book publishers), *Photographer's Market* or *The International Directory of Little Magazines and Small Presses*

(Dustbooks). Visit your local library for these reference materials. It also helps to call publishers for their current mailing addresses.

Selling Photos for Text Illustration

As mentioned previously, most money to be made from book publishers comes from sales of text illustration photos. Revenue varies depending on numerous factors, such as how the images are used, the print runs and types of rights purchased. For example, an inside photo for a book with a small print run might pay $100 or less. On the other hand, a cover image with a press run over 500,000 might be worth $4,000.

When establishing prices, one aspect to closely consider is the image value to the client. In many instances, book publishers maintain volume contracts with stock agencies. Publishers often research the stock catalogs of their contracted agencies first and turn to outside sources only if their normal suppliers don't have what they need. If you are contacted by a large book publisher, the photo buyer probably has exhausted all her normal options. Therefore, your images are of greater value to her.

When buyers turn to secondary options, they must know what you have to offer in order for you to make any sales. Submissions must include as much detail as possible about your work. If you are a stock photographer, you want publishers to know exactly what you have in your files so they can call you and request images when necessary. If you crave larger assignments, it's important to describe in detail your area of expertise and give photo editors a strong portfolio presentation.

The first selling tool in your submission package ought to be a cover letter. As mentioned in previous chapters, a cover letter should be short and to the point. Introduce yourself. Mention the fact that you are familiar with a publisher's titles, and explain your area of expertise. When possible, describe any publishing credits and perhaps include a client list. If you specialize in travel photography, it also helps to list future travel plans. A publisher might not have an immediate need for your work, but you could be heading to a location from

which the publisher needs images and might assign something to you.

Along with a cover letter, it helps to give publishers stock lists to keep on file. Stock lists essentially describe the subjects you have photographed. For some photographers with thousands of images, the list may only provide a sampling of what's available. The important point is to itemize as many subjects as possible in great detail. For example, if you're a nature photographer, tell what animals you have photographed, including the species names. (Don't just state that you have photos of wildlife.) Then buyers can review your stock list when they need images.

Finally, include a self-promotion piece and a self-addressed, stamped envelope for anything that needs to be returned. Buyers love promo cards with a few of your best images, your name, address and phone number. They may not have an immediate need for your work, but a promo card can be posted or filed in a drawer as a reminder of your work.

Avoid sending original images unless the buyer makes such a request, and then make sure you send the package via certified mail. Most buyers don't accept unsolicited submissions because they don't want to be held liable for lost or damaged images. Plus, reviewing images, especially those that aren't of good quality, eats up a lot of their time.

Publishers usually keep images over a period of months while books are being laid out. Whenever possible, only send good-quality duplicates and keep the originals in your files so they are available for other requests.

Selling Book Ideas

Attracting buyers to your stock files is a lot different than attempting to have a publisher produce a complete book of your photographs. Selling images for text illustration requires you to inform buyers of what photos you have available on a broad scale, while a complete book project demands explanation of one specific theme you intend

Sample Cover Letter for Book Publishers

March 15, 1997

Joe Nidy
Flying High Images
1234 Fancy Photo Way
Cleveland, OH 44122
(555) 555-5555

Research to find current contact name.

Robin Feldman
Big Bird Publishing
128 Larkspur Drive
Greenville, SC 29611

Dear Ms. Feldman:

Explain reason for writing.

In perusing my local library, I noticed a large selection of books on birds of prey that were published by Big Bird Publishing. As a photographer who specializes in birds of North America, I wanted to introduce myself to you with the hopes of fulfilling your future photography needs.

Cite credentials.

Include stock list.

I've spent the past 10 years documenting birds in their natural habitat and have amassed a large collection of images from throughout North America, including northern Canada, Alaska and parts of Mexico. Enclosed is a partial list of available photographs in my files. I noticed in reviewing many of your field guides that Latin names are often listed, so I've included this information as well.

Mention past accolades.

I have earned awards from the Sierra Club, Oxbow Inc. and the National Wildlife Federation, and have published in more than a dozen wildlife magazines. And, as a member of the National Audubon Society, I frequently lecture about birds and their habitats.

Always include SASE.

May I send you my portfolio or samples of my work to give you a better understanding of my photographic talents? Enclosed is an SASE for your reply.

Best regards,

Joe Nidy
Photographer

Sample Stock Photo List

Joe Nidy
Flying High Images
1234 Fancy Photo Way
Cleveland, OH 44122
(555) 555-5555

Specializing in Birds of North America

Stock List (new subjects since January 1997)

Birds of Prey
American Kestrel (*Falco sparverius*)
Bald Eagle (*Haliaeetus leucocephalus*)
Barn Owl (*Tyto alba*)
Barred Owl (*Strix varia*)
Cooper's Hawk (*Accipiter cooperii*)
Great Horned Owl (*Bubo virginianus*)
King Vulture (*Sarcoramphus papa*)
Osprey (*Pandion haliaetus*)
Peregrine Falcon (*Falco peregrinus*)
Red-Shouldered Hawk (*Buteo lineatus*)
Red-Tailed Hawk (*Buteo jamaicensis*)
Sharp-Shinned Hawk (*Accipiter striatus*)
Snowy Owl (*Nyctea scandiaca*)
Swainson's Hawk (*Buteo swainsoni*)
Swallow-Tailed Kite (*Elanoides forficatus*)
Turkey Vulture (*Cathartes aura*)
White-Tailed Kite (*Elanus leucurus*)

Ducks and Other Swimming Birds
American Black Duck (*Anas rubripes*)
American Wigeon (*Anas americana*)
Arctic Loon (*Gavia arctica*)
Atlantic Puffin (*Fratercula arctica*)
Brown Pelican (*Pelecanus occidentalis*)
California Gull (*Larus californicus*)
Canada Goose (*Branta canadensis*)
Caspian Tern (*Sterna caspia*)
Cinnamon Teal (*Anas cyanoptera*)
Common Tern (*Sterna forsteri*)
Double-Crested Cormorant (*Phalacrocorax auritus*)
Iceland Gull (*Larus glaucoides*)
Ivory Gull (*Pagophila eburnea*)
Leach's Storm Petrel (*Oceanodroma leucorhoa*)
Mallard (*Anas platyrhynchos*)
Mottled Duck (*Anas fulvigula*)
Mute Swan (*Cygnus olor*)
Northern Gannet (*Morus bassanus*)

Your name, address and phone, usually on letterhead.

Regularly update your stock list.

Include Latin names for wildlife.

Common names for wildlife.

Pied-Billed Grebe (*Podilymbus podiceps*)
Red-Necked Grebe (*Podiceps grisegena*)
Royal Tern (*Sterna maxima*)
Whistling Swan (*Olor columbianus*)
White Pelican (*Pelecanus erythrorhynchos*)
White-Tailed Tropicbird (*Phaethon lepturus*)
Yellow-Billed Loon (*Gavia adamsii*)

Passerine (Perching) Birds
Barn Swallow (*Hirundo rustica*)
Black-Billed Magpie (*Pica pica*)
Carolina Chickadee (*Parus carolinensis*)
Carolina Wren (*Thryothorus ludovicianus*)
Chimney Swift (*Chaetura pelagica*)
Clark's Nutcracker (*Nucifraga columbiana*)
Cliff Swallow (*Petrochelidon pyrrhonota*)
Eastern Kingbird (*Tyrannus tyrannus*)
Eastern Pewee (*Contopus virens*)
Great Crested Flycatcher (*Myiarchus crinitus*)
Northern Mockingbird (*Mimus polyglottos*)
Red-Breasted Nuthatch (*Sitta canadensis*)
Water Pipit (*Anthus spinoletta*)
Western Kingbird (*Tyrannus verticalis*)
White-Breasted Nuthatch (*Sitta carolinensis*)
White-Necked Raven (*Corvus cryptoleucus*)

Wading Birds
American Avocet (*Recurvirostra americana*)
American Flamingo (*Phoenicopterus ruber*)
Common Snipe (*Capella gallinago*)
Glossy Ibis (*Plegadis falcinellus*)
Great Blue Heron (*Ardea herodias*)
Killdeer (*Charadrius vociferus*)
Least Bittern (*Ixobrychus exilis*)
Lesser Golden Plover (*Pluvialis dominica*)
Reddish Egret (*Dichromanassa rufescens*)
Ruddy Turnstone (*Arenaria interpres*)
Snowy Egret (*Egretta thula*)
Snowy Plover (*Charadrius alexandrinus*)
Solitary Sandpiper (*Tringa solitaria*)
Spotted Sandpiper (*Actitus macularia*)
Virginia Rail (*Rallus limicola*)
Whooping Crane (*Grus americana*)
Wood Stork (*Mycteria americana*)

Send promotional materials on a regular basis. →

Call (555) 555-5555 to receive a complete stock list or to be placed on a mailing list for periodic updates.

to cover. The projects themselves can encompass almost any topic, as long as the final product has focus.

It is not uncommon for books to arise from other assignments. Photojournalists, for instance, who cover events for magazines, newspapers or news services often discover larger, more compelling stories. These stories may be too large to be covered with one or two photos in a magazine, so books become the best avenue for complete coverage.

Once you have a theme for your book, the first step is to develop a proposal that explains your idea and gives the publisher an understanding of your technical ability. The proposal needs to be well researched and should answer the most obvious question the publisher will have regarding the project: "Will readers buy this book?" Having a great idea for a book is important, but it's more important to have a great idea for a book that will sell.

There are ways to find out if your book will interest readers. First, discuss your proposal with bookstore buyers, specifically, the people in charge of purchasing the type of book you want to publish. Does the concept interest them? Do they think readers will find it appealing? How can you make the book more appealing? Are there any books already on the market that are similar to yours, and are those books selling?

Once you've compiled your research, include your findings in a query letter that is sent to publishers along with an author bio and samples of your work. If the idea requires a table of contents, it might be wise to include a sample one that gives the publishers an idea of what you intend to cover. Meanwhile, the query letter will give an overview of the project and explain the need for such a book.

You'll note in my sample query letter on page 120 a couple key points:

- This letter is loaded with research. Facts are provided to back up my claim that this is an important issue that should be covered in book form. The specific reader interest information in paragraphs five and six bolster my claims that the book will sell.

Sample Query Letter for Book Proposal

June 26, 1997

Sandi Johnson
Casino Pictures
1234 Cherry Lane
Las Vegas, NV 89111
(555) 555-5555

Research to locate current contact.

Jack Singer
Fun and Games Publishing
128 Larkspur Drive
New York, NY 10012

Dear Mr. Singer:

Describe your idea.

For the past five years, I've traveled around America documenting life in and around casinos. Gambling is no longer limited to the glitzy hotels of Las Vegas, Reno and Atlantic City. Riverboats and large casinos are popping up throughout the country. And they're thriving.

Show knowledge of the client.

My work has resulted in a large collection of interviews and photographs that would make an excellent book for Fun and Games Publishing. *Casinos: America's Newest Addiction* takes a candid, often sad, look at people who have let gambling overtake their lives. The book also contains interviews with many top casino executives who spoke openly about the industry and its effects on society.

Fun and Games Publishing has produced several books on the subject of horse racing and other gaming activities, but this would be the first title to examine casino gambling. It's an industry that adds millions of dollars in taxes and business development for communities, but at the same time strips some municipalities of their moral character.

And it's an industry about which people are interested in reading. Consider this:

Strengthen your book idea with facts and research.

—Circulation figures for casino industry magazines have risen 45% in the past five years.

—Since 1995, six pocket guides that teach people how to gamble have sold more than three million copies. (See the enclosed article from *Publishers Weekly*.)

Also of interest is the fact that seven states have approved casino gambling in the past three years, and five more states plan to hold referendums on casino gambling in November's elections.

Provide a tentative outline and sample images.

Enclosed you will find a sample Table of Contents for this book, a bio for myself and a few promo cards for your review. Please contact me if you'd like to discuss this book or see more photo samples from this project. If I don't hear from you by October 1, 1997, I will assume your company is not interested in my idea and I'll pursue other publishing options.

Provide deadline for review.

Best regards,

Sandi Johnson

OBTAINING FUNDING

In some cases, it is possible to acquire funding for book projects from an outside source. Perhaps you're interested in documenting inner-city poverty, habitats of endangered species or other social issues. In certain instances, nonprofit organizations or foundations, even local, state or national government offices, may provide funding for your project. If you think your book could be a candidate for funding, visit your local government offices or library to research such possibilities.

• I inform the publisher that I know the titles he publishes and see a hole in his line of books. This hole can be filled with my book.

• Enclosures are provided that should help him assess my book idea and my skill level. Always include a table of contents and photo samples. In this instance, I even added an article from *Publishers Weekly* to lend support to my proposal.

• I provided a deadline for review to keep the publisher from sitting on the proposal forever. Three months is plenty of time for anyone to respond to a book proposal. Plus, some publishers dislike simultaneous submissions, and this deadline shows him that he is the only one reviewing this idea.

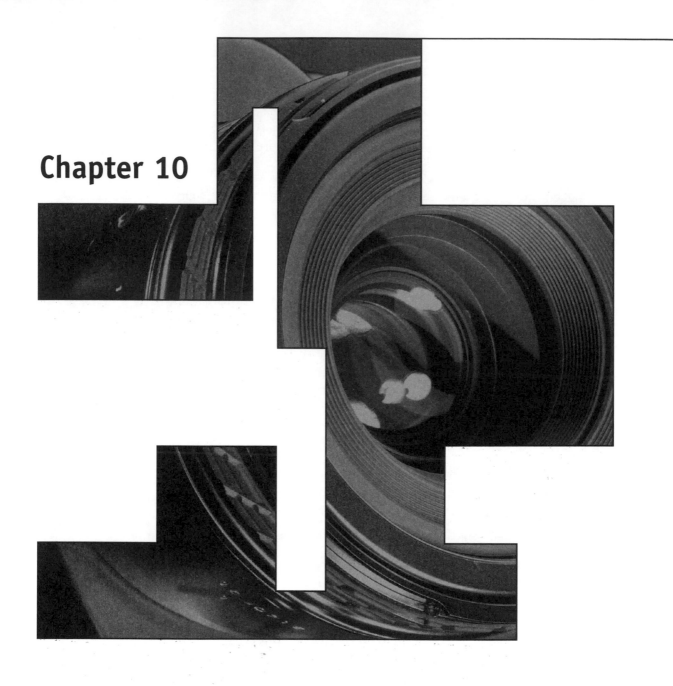

Chapter 10

Commercial Clients

There are two distinct areas of professional photography within which most freelancers work: editorial and commercial. Editorial photographers are those who seek publication in magazines, newspapers and book publishing. As a general rule, buyers in editorial photography pay less than those seeking commercial work. Commercial clients include large corporations, advertising agencies, public relations firms and design studios. While editorial shots are used to sell stories or illustrate articles, commercial images are used to sell products and promote companies.

Sales to media buyers, such as advertising agencies, public relations firms and design studios, can generate tremendous amounts of income for freelance photographers. The companies work with large corporations on national ad campaigns, brochures, even product designs, and, therefore, they pay big money to help shape public opinion of their clients.

If you want to work with Fortune 500-type companies, find out who handles their advertising accounts, designs their annual reports or company newsletters, or distributes their press releases. Often this work is handled by outside agencies, and those are the people you must contact to garner assignments. However, you may discover that in-house public relations offices and art departments produce these materials.

Selecting Buyers for Your Work

New photographers entering this market may have a difficult time landing assignments with commercial clients. Art directors have their favorite freelancers, and rather than take risks with unproven talent, they prefer to use photographers with whom they've worked before.

There are times, however, when new blood is needed. Most ad agencies are willing to at least review work from newcomers so they don't miss emerging talent. It also helps that clients tire of the same "look" in their ads or annual reports and start demanding something fresh and exciting. This puts demands on ad agencies, public relations firms and design studios to find photographers with unique styles.

Previous chapters covered the essentials of contacting new clients,

such as avoiding long phone conversations with buyers while they're on deadline, getting the names of current buyers and spelling them correctly. These aforementioned ideas apply in the commercial photography field as well.

However, along with knowing whom to contact, you need to determine whom you want to contact. Not all ad firms, for example, will live up to your standards. Stick to those clients who produce top-notch work and can enhance your career, and leave the inferior clients to the less knowledgeable photographers.

But how can you select a company to which you would like to submit work? First, take a look at what's on the market. Magazines, product packaging and promotional materials can help you decide which clients you want to approach. See what you like and find out who's creating it. Take time to review the trade magazines that are published for these industries. Such publications list award-winning ads, self-promotion pieces, brochures, etc., and they often state who worked on the projects. This can be important when you write a quick cover letter introducing yourself to a potential client.

Portfolio Presentations

Once an art director is sold on your style, he will probably ask you to attend a portfolio review. Chapter six talked primarily about the physical makeup of a portfolio but didn't discuss the actual presentation that is key to your success.

Below is a list of dos and don'ts that should help you land assignments.

Do

- **Present a portfolio that looks professional.** This was discussed before, but it's important to understand that most art buyers won't waste their time with photographers who can't properly promote themselves.

- **Let the art buyer review your portfolio at her own pace.** Don't stop her from looking at a piece in order to discuss another image

Sample Quick Cover Letter

March 21, 1997

Dusty Rhodes
Auto Images
455 Race Lane
Cincinnati, OH 45222
(555) 555-5555

John Farley — Current contact.
The Ad Agency
333 121st Street
New York, NY 10022

Dear Mr. Farley:

I noted with interest your award-winning advertisement for General Motors that — Show knowledge of client.
was listed in the latest *Communication Arts*. As a photographer who specializes in
images of high-performance automobiles, I know how hard it is to be original with
a big hunk of metal.

Enclosed are some promotional materials for my studio along with a list of former — Request portfolio review.
and current clients. Please hang onto the promotional shots, and, if you're inter-
ested, I'd love to show you my latest portfolio. Please contact me at your earliest
convenience.

Warmest regards,

Dusty Rhodes
Photographer

you like. If she is taking a hard look at a photo, she might have a future project in mind.

• **Sit back, watch and listen.** You can learn a lot about your portfolio by seeing how an art buyer reacts to certain photos. If she briefly reviews a piece, consider removing it from your portfolio, especially if three or four art buyers have done the same thing. Likewise, if buyers continually ask about the same piece, be certain to move the piece to the front of your portfolio.

• **Make sure the buyer is focused on your portfolio during the review.** Phone interruptions or other distractions can cause an art buyer to miss something valuable in your portfolio. If an interruption occurs and you feel a buyer has skipped over some pieces, ask her, nicely, to take a second look.

• **Supply a cross section of black-and-white and color images.** Buyers want to see variety.

• **If you are being considered for a specific project, find out if bids are being accepted.** If so, find out if the bids are competitive or comparative. With competitive bids, art buyers must accept the lowest bid for a project, regardless of quality. With comparative bids, the best photographer gets the assignment, regardless of price. Make certain the buyer wants quality rather than a low price.

• **Leave a promo card.** This will keep your name in the art buyer's mind.

• **Find out what happens next.** Is the buyer interested in your style or not? If so, does she have an immediate need for your work? If not, does she have any suggestions for improving your portfolio?

• **Follow up.** Send a thank-you card about a week after your portfolio review. Once again, this keeps your name fresh in an art director's mind. After a month or so, call the art buyer to see if any assignment possibilities are looming.

Don't

- **Attempt to make friends with art buyers you don't know.** Small talk about subjects unrelated to your work can backfire on you if you're not careful. It's best to stick to the business at hand—your portfolio.

- **Bid on projects in which the lowest bid gets the job.** This devalues the price of your work and will give you a reputation for supplying "cheap" photographs. It's better to have a reputation for "being worth the money."

- **Pad your portfolio with mediocre images.** Only present your best work, even if that means showing just ten photographs. The weak shots will get noticed and may prevent you from getting an assignment.

- **Get offended by criticism.** Skilled art buyers know what works and what doesn't. If you hear the same criticism about your book from several different buyers, chances are they're right.

- **Have images that are too big to present.** There's no need for poster-size prints. Keep your portfolio to 11×14 or smaller.

- **Jump from one format to another.** For example, if you shoot 35mm, decide on either a slide presentation or prints, not both. This only distracts viewers.

Comp Usage and Fees

When submitting stock photos for review with commercial clients, it's possible they will place one of your images inside a layout and show the idea to superiors or clients. This practice is called "comping" and is designed to help sell an idea. Often, images from stock catalogs are used in this manner.

Some photographers have begun charging clients a small fee for comp usage. The reason being that the photo, oftentimes, is what sells the layout to the client. In many cases, the comp fee is deducted from the final cost if the layout results in a sale or assignment.

In some instances, agencies use the work of one photographer for comp purposes and then hire a different, less expensive photographer to produce the finished product. If this happens to you, investigate legal options you might have for a copyright infringement case (see discussion of copyright in chapter five). If you find you have no legal grounds for a copyright infringement suit, you may decide not to approach the same client in the future.

There are other situations in which the comp is a sketched layout. Sometimes the client approves this comp before the photo assignment is made; other times the assignment is completed and the finished project is presented to the client for acceptance. Find out from the art buyer if the layout has been preapproved. This will give you some bargaining power during price negotiations.

If you are assigned to shoot a project using a comp that has been preapproved, be certain to give the buyer an image that looks like the accepted layout. While it's good to use your own ingenuity on shoots, it's most important to give buyers what they want. Any images you create by deviating from the original concept may not appeal to the client. Regardless of what you may think of the layout, shoot the assignment as it's been approved. Then fiddle around with other ideas that may be more appealing.

Take a Proactive Approach

It's extremely likely that one day you'll be flipping through a magazine or newspaper and you'll come across an ad you think contains poor photography. Or perhaps you'll visualize the perfect advertisement for a company based on one of its products. In each of these situations, you believe you can do a great job for this client if given the opportunity. So how can you turn such ideas into assignments?

The key is to be proactive. Don't wait for clients to find the perfect assignment for you based on your portfolio or self-promotion pieces. Approach them first. As mentioned previously, clients must know you can solve their problems. An easy way for this to happen is to show them you understand their companies and, therefore, their photo needs.

One of the easiest ways to show you comprehend their needs is to pay attention to the news. Magazines, newspapers and TV reports can give you plenty of fodder for potential assignments. You'll also find that many businesses are often too close to their everyday activities to know when good promotional opportunities occur. It's up to you to point out these items to build photo opportunities for yourself. Consider the following:

- There are plenty of companies that expand their workforces. Why not complete a self-assigned project tackling the theme of prosperity and job security? Show these companies your work, and offer to produce a series of posters for their office walls.

- Lots of businesses relocate because they've outgrown their current facilities. Perhaps they need photos for press releases that announce such moves.

- Companies often introduce new products. These products will need to be photographed for advertisements. Photograph other products they have manufactured, and show them you can present their goods in fabulous ways.

- High-profile job announcements often require portraits for news articles. If you know a person has been hired to a new position, send a promotional piece that congratulates him on his new job. Offer your services for portraits, and include a sample or two. Explain that you work quickly. Most top executives have little time to waste, even for promotional portraits.

- There are often mergers and acquisitions between companies. Figure out a way to communicate cooperation between workers, and offer to shoot a similar image using company employees. This photo can be used for press releases or annual reports.

Chapter 11

Paper Product/Gift Producers

The paper products/gifts industry remains one of the largest markets for photographers. It includes a wide array of different buyers who annually produce billions of dollars worth of products, such as greeting cards, postcards, calendars, posters, and even magnets, T-shirts and gift bags. It's a market known for buying millions of images, but it also has a reputation as a low-paying market.

For stock photographers, these companies are ideal for making extra money. Buyers range in size from small producers with limited distribution areas to major companies that own most of the market share (such as Hallmark, Gibson Greetings, Landmark Calendars and American Greetings). Since these markets are so stock driven, they should not be approached by photographers banking on assignments. Although some buyers offer assignments, opportunities for these types of sales are limited.

In this area, there are two ways to sell your work. The first is through licensing, in which buyers either pay a negotiated flat fee to use your work or offer royalties based on overall sales. (Royalties on greeting cards bring in about 5 percent per card sold, while sales of individual images typically generate $50 to $500 per photo.)

The second way of selling to these companies is by self-publishing products and distributing them. There are plenty of photographers who print postcards, calendars and greeting cards and market their own goods. Or they hire sales reps to market merchandise to clients. I'll discuss the specifics of self-publishing later in this chapter.

Locating Buyers

If you're interested in licensing your work, you must first find buyers. There are resources to help you with this task, such as *Photographer's Market* and *Party & Paper Retailer* (4Ward Corp.). These tools list names and addresses of buyers. However, the best way to locate potential clients is by visiting retail outlets, including grocery stores, novelty shops, card stores and many other outlets.

As you peruse the shelves, find products that contain photos similar in style to your work. For example, some greeting card lines are strictly humorous; others contain landscapes and sensitive prose. If

Pricing Your Work

When a buyer is interested in your work, remember to negotiate based on the end usage of your photos. Many buyers in the paper products/gifts industry prefer to acquire all rights to images so they can use them for various projects. If you agree to sell all rights, make certain you are fairly compensated.

The list of resources below can greatly improve your understanding of pricing in all aspects of photography. Consider using some of these tools in order to keep yourself from losing valuable income.

fotoQuote—Developed by Cradoc Bagshaw and stock photographer Vince Streano, fotoQuote is a sleek image-pricing software used by photo professionals at all levels. The latest version (fotoQuote 2.0) allows buyers to plug in various criteria for stock and assignment work while creating prices for both editorial and commercial markets. Cost is $129.95 (plus shipping and handling). Contact the Cradoc Corporation, 145 Tyee Dr., Suite 286, Point Roberts, WA 98281, (800) 679-0202.

Pricing Photography: The Complete Guide to Assignment & Stock Prices—Published by Allworth Press, this book by Michal Heron and David MacTavish gives plenty of sample charts and step-by-step instruction for anyone who has trouble negotiating fair prices.

Negotiating Stock Photo Prices—As the title implies, this book, written by stock industry guru Jim Pickerell, focuses on pricing strategies for stock photographers. It is ideal for beginners who want to be certain they're not being shortchanged by buyers.

you create one of these types of materials, find out who produced the cards and make a list of those companies. Note whether the products typically give photographers credit lines. Also, check prices, image quality and how the products are displayed. All of this helps during negotiations and while selecting markets to approach.

The above steps may seem time consuming, but there are rewards to conducting such research. You won't waste postage on clients who

don't use the type of work you shoot. Buyers will appreciate the fact that you understand their product lines. And, as mentioned before, you'll benefit during negotiations. For instance, if a client requests all rights to an image and you've noticed in reviewing her products that photographers have traditionally kept their copyrights, you'll know not to sell all rights to your images.

After you've developed a list of potential markets, contact these companies and see if they will send you photo guidelines. These guidelines provide submission directions for photographers, covering such specifics as what types of film formats they prefer, what type of subjects they want to see and deadline schedules.

It also helps to send a current stock photo list so buyers know what you have available. Be specific and as complete as possible when creating this list. Details give buyers a proper understanding of what you have on file when they start searching for images.

Submitting on Spec

Some markets accept images on speculation, or "on spec," but not all. ("On spec" means you send images with the hope that a buyer needs one or more of the selections.) If you plan to mail photos on spec, be certain the buyer is willing to review material in this manner. Some buyers get flooded with speculation mailings or simply don't want the responsibility of caring for images they did not request. Therefore, they have policies against such submissions.

If a client agrees to review images on spec, there are a couple steps you should take to enhance your chances for success. First, don't send original materials. Transparencies can be duplicated for a fairly low fee. It's also possible to send prints instead of negatives. This simple step will give you some protection from unscrupulous buyers who don't return images, and if the material gets lost or damaged in transit, you won't lose the best-quality images.

Submit original images only on request, and then make certain to submit them via registered mail or through a shipping service such as Federal Express or United Parcel Service. This will enable you to track your work in the event something goes wrong.

Make a habit of researching potential markets prior to submitting photos. Paper product/gift companies often develop entire product lines on an annual basis. They know, for instance, that their swimsuit calendars will be out every summer or that graduation cards come out in the spring. Learn the annual cycles for companies and the deadlines for their product lines. This will be a simple way to give buyers what they need at the right time of year. And it might result in future sales from repeat clients who are impressed with your knowledgeable approach.

Another way to research company needs is to review photo industry trade newsletters. Publications such as *The Guilfoyle Report* and *Photo Stock Notes* often list photo needs for paper product/gift companies. These publications are great resources for finding leads to clients who immediately need stock images.

If you intend to approach a fine art publisher or a company that produces large calendars, be certain your film quality is up to buyer standards. For example, slide film speeds faster than 100 ISO do not lend themselves to large reproduction formats. There is a reduction in resolution quality and overall color saturation when the images are enlarged to poster size. Therefore, check with buyers to see if they have any film preferences or limitations on transparency formats.

Finally, when you mail images on spec, be certain they are properly packaged. All work should be tucked inside archival-quality plastic sleeves and mailed with an SASE. Include a cover letter that describes the material you're sending. Also enclose a promotional piece that can be stored by the client for future reference.

Self-Publishing Options

In some instances you may believe you would have greater success self-publishing a poster, calendar or postcard than trying to license your work to someone else. Depending on the amount of money you have to spend on such a project, self-publishing can be a viable option for selling your work. The key is understanding the sales avenues that are open to you once the product is produced.

As a self-publisher, you must assume the burden of designing your

product and getting it printed, packaged and distributed to retailers. Since the paper products/gifts market covers everything from fine art prints to key-chain trinkets, this can be extremely difficult. It will take time to produce the product, but it will take even more time to get retailers to sell your product in their stores. Banging on doors is an option, but it's not a favorite among creative photographers who would rather be shooting new photos.

The best way to handle sales to retailers is to commission sales representatives in the industry to sell your products to their clients. They already have established clientele and can save you valuable time. You can negotiate commissions (perhaps 5 to 10 percent) based on overall product sales. You can pay a flat fee for their services, but a rep who gets paid based on what he sells might work harder for you.

Before you produce any pieces on your own, talk to store owners and find out how they buy products. Get the names of the sales reps who sell to them in order to build your list of potential salespeople for your products. Show retailers your work and see if they think such photos will sell as posters, calendars or greeting cards. And don't limit yourself to one or two buyers—talk to as many as possible. They can help you determine which photos to publish and might be able to give you some preliminary sales figures.

Discuss the project with various printers, and obtain cost estimates from them. It might cost you $5,000 to $10,000 to get a quality poster printed, so you want to be certain the printer you select can do a solid job for you.

Because the cost of producing such pieces can be expensive, remember that it's also possible to collaborate with designers or illustrators on such pieces. They may be interested in splitting the production costs in exchange for a share of the overall profits. And remember, anything you produce in this area can work extremely well as a self-promotion piece.

Chapter 12

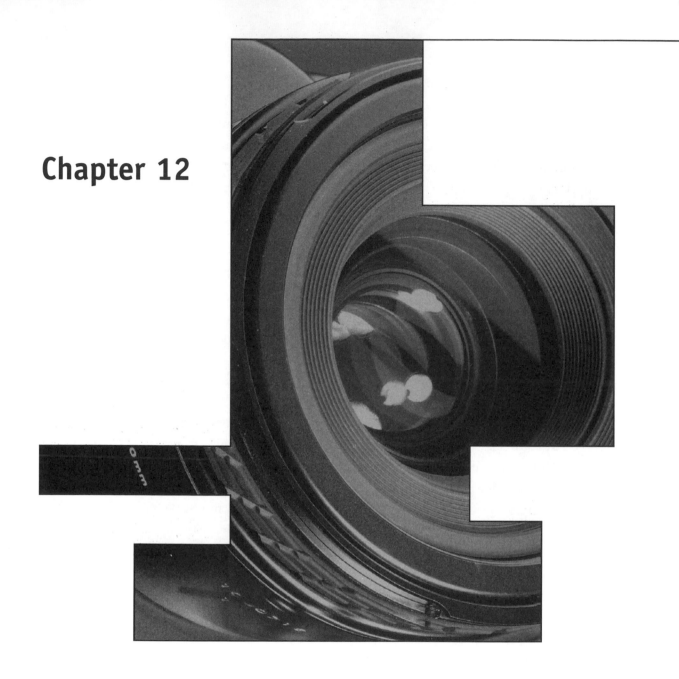

Galleries

The popularity of photography as a collectible art form has improved the market for fine art photographs over the last decade. Viewers now recognize the investment value of prints by Ansel Adams, Irving Penn and Henri Cartier-Bresson and therefore frequently turn to galleries for stirring photographs to place in their private collections.

The gallery/fine art market is one that can make money for many photographers (see chapter four for discussion of gallery representation). However, unlike the commercial and editorial markets, galleries seldom generate quick income for artists. Galleries should be considered venues for important, thought-provoking imagery, rather than markets through which you can make a substantial living.

More than any other market, this area is filled with photographers who are interested in delivering a message. Whole shows often focus on one overriding theme by a single artist. Group shows also are popular for galleries that see promise in the style of several up-and-coming photographers.

It might be easiest to think of the gallery market as you would book publishing. The two are similar in that dozens of pictures are needed to thoroughly tell a story or explore a specific topic. Publishers and gallery directors are interested in the overall interpretation of the final message. And they want artists who can excite viewers to think about important subjects and pay for photographs that pique their emotions.

Contacting Gallery Directors

There are dozens of resources available that list galleries. *Art in America* magazine, for instance, lists hundreds of galleries by region and describes those that are interested in photography as a medium. If you are just entering the gallery scene, it might be best to stick with markets near you. Your local phone book lists galleries in your area, and by visiting them in person, you will get a better understanding of how galleries operate.

As with picture buyers and art directors, gallery directors love to see strong, well-organized portfolios. Limit your samples to no more than twenty top-notch slides or prints. When putting together your

portfolio for this market, it's essential to package images that focus on one overriding theme. A director wants to be certain that if you are given a solo exhibition, you have enough quality work to carry an entire show. After the portfolio review, if the director likes your style, you might discuss future projects or past work you've done.

Directors who see promise in your work but don't think you're ready for a solo exhibition may place your material inside a group exhibition. In group shows, numerous artists display work at the same time. You might even see different mediums, such as photography, illustration or abstract sculptures, on display simultaneously. The emphasis of a group show is to explore an overriding theme from various perspectives. Such shows can be juried, which means participants have been accepted by a review committee, or nonjuried.

When searching for a gallery to exhibit your work, you may find some that accept slide or print submissions for review rather than formal portfolios. Call to see what the gallery prefers, but remember to concentrate on an overriding theme. When you mail submissions, include a cover letter, a resume, an SASE and an artist's statement.

There is a difference between a resume and an artist's statement. The resume gives general information about what you've accomplished in your career and some basic background on your education. An artist's statement is a short essay that discusses your work. No more than a paragraph in length, your artist's statement should describe your creative thinking process. Such a statement gives the gallery director an understanding of what you plan to convey in an exhibition of your work.

Each photographer will have a different artist's statement that explains the creative process behind her work. This statement should take some thought and provide some insight into you as a creative person. Before you write your artist's statement, consider these two key questions:

- Why do you photograph certain subjects?

- What do you hope viewers will take with them after seeing your work?

Use your answers to these questions to fashion a statement that is candid and real. There is no need for lengthy prose or inflated language. Gallery directors want to understand the person behind the photography. They don't need to be impressed with how well you write. The sample artist's statement on page 140 should help you create an essay of your own.

Preparing Your Work for Exhibitions

If a gallery director likes your work, it will be up to you to prepare photos for an exhibition. Often this means providing images that have been matted and framed. Remember, you don't want flashy mats or frames to detract from your photographs. Black-and-white photos look great with white mats and plain black frames. For color images, neutral colors work best.

If you don't know how to mat or frame your photos, have them done professionally. Start a new framer with a couple photos to see how he does before giving him large amounts of work. This is one area where spending some extra money may be worth the investment.

Pay particular attention to proper storage of your work. How you store photos is extremely important to the overall quality of your photographs when they are displayed. All photographs should be printed on acid-free paper, and any mats you use also should be acid-free. Store prints flat beneath a piece of acid-free foamcore board, and make certain the room in which you store your photos does not contain a lot of moisture in the air. Moisture can cause mold to develop, which will ruin photographs. Archival-quality file cabinets designed to handle poster-size prints are available.

Alternative Spaces

Don't limit yourself to galleries if you hope to exhibit fine art photographs. There are plenty of alternative spaces for displaying your work, and many times they are more receptive to displaying the work of newcomers. Page 141 lists places to consider if you are interested in exhibiting work in alternative spaces.

Sample Artist's Statement

Keep statement focused and brief.

The Artist's Statement

I've always been fascinated by male-female relationships in all walks of life. There is a range of emotions that consumes both genders. How they express such feelings toward each other is the essence of my work. Love, hate, frustration, exuberance, sorrow— all these sensations are captured in my pictures. My hope is that viewers will ponder what they see and come away with a better understanding of, and appreciation for, the people around them.

- Airports

- Banks and other financial institutions

- Camera stores and film processing centers

- Corporations

- Doctors' offices and other health care providers

- Governmental offices

- Hotels

- Attorneys' offices

- Movie theaters

- Nonprofit organizations

- Restaurants

- Retail outlets, such as gift shops and department stores

Don't assume that since these outlets don't specialize in selling art-work they have less value than galleries. In fact, nontraditional outlets might serve you better than galleries. Foot traffic might be better in an alternative space. Therefore, depending on where your work is displayed, more viewers might result in more sales.

Another benefit to an alternative space is that commissions on sales may not be as high. These businesses may not normally hold exhibits, so they may accept a smaller commission than a gallery. After all, they are getting great photography for decoration purposes and some extra income, without doing anything except hanging a few pictures on their walls.

The downside to placing work in an alternative space is that most of these outlets call for conservative imagery. As a rule, landscapes, flowers and other "feel-good" photos will be more accepted than nudes or photos depicting hard-hitting social issues. The reason is that, even if they love your work, most businesses do not want to offend their patrons.

Chapter 13

Contests

It seems every magazine, corporation, school and organization holds an annual photo contest. Amateurs and professionals worldwide are encouraged to enter hundreds, if not thousands, of contests annually. Some pay cash or award grants to the winners; others give prizes that are not monetary, such as cameras, trips or publication opportunities.

If you like entering contests, there are some ways to improve your chances of winning. In this chapter we'll examine some of the important issues and give you tips on selecting images that will impress the judges.

What makes a photo an award winner? Is it creativity or technical strengths like outstanding lighting, eye-popping colors and stunning composition? Perhaps awards are given only to those images that force viewers to contemplate major issues or become attached to the subject matter in some way.

There's no recipe for success. All these points are taken into consideration when judges start pitting one image against another. The key to winning contests is understanding that the selection process is far from finite. I've won photo contests in the past, and I can honestly say there was little difference between the quality of my photos and those of the second- and third-place finishers. For one reason or another, the judges liked mine over the others.

Everyone has opinions about what makes an image great. The trick is to find out who is judging the contests and what appeals to them.

Scouting Out the Judges

Before you enter a contest, do a little research. Contest sponsors can tell you who is judging their competition. You also might find this information on the entry form, especially if the judges are well known. Most contests use more than one judge, and often they are teachers, picture editors, photographers, or are affiliated with the sponsors.

If a judge is a picture editor or photo editor for a magazine, you can learn a great deal about his tastes by reviewing back issues of the publication. You can see what styles are used in the magazine and, therefore, understand the judge's tastes. Familiarize yourself

with the names of the photographers in the publications. You should be able to tell what editors like by knowing who they hire on a regular basis.

As you review these publications, limit your research to the past year or two. Everyone's tastes evolve. By going back too far in your research you may actually hurt your chances by uncovering styles that are passé and no longer interesting to the judge you're researching.

Some photographers also judge contests, and they might favor contestants who match their own style of photography. Study the recent work of a judge if he or she works as a photographer. How is lighting used to enhance their photos? What tips can you get from the way they compose or crop their photos? Are they interested in digital imagery or special effects? What subjects do they shoot? Considering all of these questions will give you an edge when selecting your entry.

Also, many of the top names in photography judge several different contests each year. Judging the contest you plan to enter may even be an annual gig for them. Scrutinize winning entries from other contests in which your judges participated. You might see some patterns in who they chose as the winners.

Following the Rules

Regardless of whether or not you understand the judges' tastes, it's most important to follow the rules. Some judges are sticklers for guidelines and will disqualify anyone who ignores the established criteria for each entry. Some rules may seem arbitrary and unnecessary, but they are in place for a reason. You're better off following them exactly instead of ignoring a few points on the entry form and hoping contest organizers or judges won't care.

The most essential rule to follow deals with the subject matter that's appropriate for the contest. Most competitions are judged in a similar fashion. Judges make an initial pass over all entries and remove those that are obviously not top contenders. For example, images that are out of focus, overexposed, underexposed or have poor quality are immediately eliminated. Also, photos with subjects that are inap-

propriate for the contest are removed. For example, contests for wild-life subjects don't want architectural shots. You may have an outstanding photo with award-winning potential, but if the subject matter isn't suitable for the contest, don't enter it. You'll only waste money on entry fees and postage.

One rule that is sometimes unmentioned relates to contest sponsors. If the competition is sponsored by a camera or film company, they are obviously going to select images created while using their products. For instance, organizers of the Kodak International Newspaper Snapshot Awards don't want to receive entries shot on Fuji film. Such stipulations may not appear in the contest rules, so when you enter a contest pay attention to the sponsors to avoid being overlooked because of the equipment you use.

Picking the Right Contest

This brings us to an important step in the process—selecting a contest that's right for you. Contests range in size from the local fairs and art shows to worldwide competitions, such as Pictures of the Year and the World Press Photo Contest. Obviously the larger, more prestigious contests will have tougher competition. If you're a newcomer to photography and have not yet built up a reputation in the field, consider entering smaller competitions to gain experience with the process.

Several points to consider when selecting a contest to enter:

• **Eligibility.** Qualifications vary for each competition. For example, some only want images from professionals, others restrict participation to women. You also might automatically be ineligible if you or a family member is employed by a contest's sponsor. Before you send anything make certain you are eligible to enter.

• **Format.** Some competitions demand that prints be provided for exhibition purposes. If you have images on transparency film only, you must determine whether it's worth the expense to get prints made of your work. Also, some competitions limit entries to black-and-white photos, while others specify that photos must be in color.

If you work only in black and white, you obviously have no chance at winning a contest for color images.

• **Subject Matter.** The most important facet of each contest has to do with the images sponsors want to receive. As discussed earlier, if you send material that's inappropriate for the competition, it doesn't matter how good the work is. You will be automatically disqualified. Limit your entries to those competitions that seek the kind of subjects you photograph.

• **Entry Fees.** Some contests charge substantial fees for entering. You must consider the cost in relation to your overall budget and the value of winning the contest. For instance, paying $20 to enter a prestigious contest like the Pulitzer Prize may be worth it because of the exposure you can get from winning. On the other hand, I'd eliminate local contests that charge $20 and give the winner a blue ribbon and free film processing at a nearby one-hour shop. There are numerous competitions that have no entry fees or minimal ones to cover contest expenses. So there's no reason to break the bank when entering competitions.

• **Releases.** Some contests are sponsored by companies that may want to use the winning entries in advertisements. In these cases you probably will need to have model releases or property releases available for any images you enter. (Turn back to page 11 to learn more about releases.) If you don't have releases for your shots, you will be unable to enter contests that result in ad space for the winner.

• **Protecting Your Rights.** As you review the entry form, it's wise to search for information about image rights. Often contest sponsors want first or one-time rights to publish the winners. They may even demand promotional rights. This type of arrangement is reasonable, as long as the photographers retain their copyright at the end. However, some sponsors state that photographers forfeit their copyright once they enter their photos in competition. This is unacceptable and you should avoid such situations at all cost.

• **SASE.** Some sponsors refuse to return entries because they receive thousands of submissions and don't want to bother with sorting and returning them. Therefore, it's best to send only prints or high-quality duplicates to most contests. Others stipulate that work will only be returned to contestants who provide self-addressed, stamped envelopes. Make certain the return postage is adequate for the shipment of your material. Also, label each image you send with your name and phone number so that if a photo gets separated from the rest of your entries, it can still be returned.

The following resources can be extremely helpful in locating contests:
- *Photographer's Market*—Published by Writer's Digest Books, this resource comes out annually and lists dozens of photo contests worldwide. Check your local library or bookstore for the latest copy, or call (800) 289-0963.
- *PhotoSource International*—This company operated by Rohn Engh, of Osceola, Wisconsin, produces several newsletters rich with contest information. Call (715) 248-3800 for newsletter information.
- *American Photo*—A bimonthly magazine that focuses on fine art and high-end photography, this publication frequently lists some of the top photo contests. It is also a great source for learning who's who in photography. Check your local bookstore or library, or call (212) 767 6086.
- *Popular Photography*—This monthly magazine periodically lists contests and even holds one of its own, Take Your Best Shot. Copies of this publication can be found at most bookstores or libraries.

Mailing Your Entry

After selecting the images you want to submit, package them according to contest rules. For example, entry forms are common and should be filled out completely. If you have more than one entry and a separate form is needed for each, be certain to photocopy the form

enough times for each entry. Don't try to cram information for several images onto one form. This will only agitate the judges.

Also, most contests give specific instructions with regard to labeling of images. They don't want any confusion about the entries. For larger contests it is also easier to have a standard labeling format to simplify office processing of the photos. If no specifications are provided by the sponsors, always label each image with your name, address, phone number and copyright symbol since your images may get separated from each other during the judging process. If you are sending the image to a foreign country, be certain to list the country in which you live.

As with most submissions, be certain to protect your work from damage by placing each piece inside a plastic protective sheet. Slides can be doubly protected by placing a Kimac around them before they are tucked inside their plastic sheets. Next, sandwich your work between two pieces of cardboard, along with a short cover letter, your entry form and a self-addressed, stamped envelope.

Use a mail carrier with package tracking options, such as Federal Express or UPS, to guarantee that your package arrives safely to contest headquarters.

PARTING SHOT

The photography field is filled with talented photographers at all levels—from the advanced amateurs to the seasoned professionals. As a result, the battle to sell images has become extremely difficult. No longer can a photographer simply walk in off the street and land a job with the top magazines or advertising firms. Buyers simply don't have the time, and the competition for that time is immense.

However, talent in taking a photograph is only half the battle. The rest of your success hinges on your ability to market that talent. Throughout this book I've offered many tips that can help you break through the walls you're bound to face when selling your work. Now that you've reached the end of this book I hope you'll put what you've learned into practice.

As you strive to sell your work, you will notice several truths along the way. First, we are bombarded with visual imagery almost every minute of every day. We have become a society in which visual communication is almost more important than the written language. If you disagree, consider the number of computers that are being sold every day, or that print ads are relying less on copy and more on photographs to sell products.

The second truth stems from the aforementioned fact that our society has become so visual—photo sales opportunities are endless. The great war photographer Eddie Adams once told me that he refuses to buy into the gloom and doom of photo industry professionals who say there is not enough work to go around. Adams believes any photographer with talent can sell work today, because there are so many publications, agencies, etc., buying images. The trouble is, competition is stiff and only those photographers willing to battle the masses will succeed.

This brings me to the final truth. Even though I've tried to be as complete as possible, I know there is an overriding key to success that I've left out—perseverance. All the advice in the world, whether it's from this book or from some professional photography seminar, means absolutely nothing unless you have the will to succeed. You're going to face rejection along the way. How you handle rejection will make the difference between success and failure.

BIBLIOGRAPHY

Big Bucks: Selling Your Photography. Cliff Hollenbeck. Amherst Media, 1995.

Business and Legal Forms for Photographers. Tad Crawford. Allworth Press, 1991.

How to Prepare Your Portfolio: A Guide for Students and Professionals. Ed Marquand. Art Direction Book Company, 1994.

How to Shoot Stock Photos That Sell. Michal Heron. Allworth Press, 1996.

How You Can Make $25,000 a Year With Your Camera: No Matter Where You Live. Larry Cribbs. Writer's Digest Books, 1991.

Photographer's Market. Michael Willins, ed. Writer's Digest Books, 1996.

Pricing Photography: The Complete Guide to Assignment & Stock Prices. Michal Heron and David MacTavish. Allworth Press, 1993.

Professional Photographer's Survival Guide. Charles E. Rotkin. Writer's Digest Books, 1992.

Sell & Re-Sell Your Photos, Fourth Edition. Rohn Engh. Writer's Digest Books, 1997.

Stock Photography: The Complete Guide. Ann and Carl Purcell. Writer's Digest Books, 1993.

The Freelance Photographer's Handbook. Fredrick Bodin. Amherst Media, 1993.

Winning Photo Contests. Jeanne Stallman. Images Press, 1990.

INDEX